MW00830059

THE URBAN SKETCHING HANDBOOK

UNDERSTANDING PERSPECTIVE

Easy Techniques for Mastering Perspective Drawing on Location

Inspiring | Educating | Creating | Entertaining

Brimming with creative inspiration, how-to projects, and useful information to enrich your everyday life, Quarto Knows is a favorite destination for those pursuing their interests and passions. Visit our site and dig deeper with our books into your area of interest: Quarto Creates, Quarto Cooks, Quarto Homes, Quarto Lives, Quarto Drives, Quarto Explores, Quarto Gifts, or Quarto Kids.

© 2016 Quarto Publishing Group USA Inc.

Illustrations © Individual artists

Nonattributed illustrations © Stephanie Bower

First published in 2016 by Quarry Books,
an imprint of The Quarto Group,
100 Cummings Center, Suite 265-D,
Beverly, MA 01915, USA.
T (978) 282-9590 F (978) 283-2742
www.QuartoKnows.com

Quarry Books titles are also available at discount for retail, wholesale, promotional, and bulk purchase. For details, contact the Special Sales Manager by email at specialsales@quarto.com or by mail at The Quarto Group, Attn: Special Sales Manager, 401 Second Avenue North, Suite 310, Minneapolis, MN 55401, USA.

10 9 8 7 6 5

MIX
Paper from
responsible sources
FSC® C016973
www.fsc.org

ISBN: 978-1-63159-128-0

Digital edition published in 2016
eISBN: 978-1-63159-192-1

Library of Congress Cataloging-in-Publication Data

Design: www.studioink.co.uk
Cover images: front cover & right, Stephanie Bower
Back cover: Gabriel Campanario
Page layout: www.studioink.co.uk

Printed in China

THE URBAN SKETCHING HANDBOOK

UNDERSTANDING PERSPECTIVE

Easy Techniques for Mastering Perspective Drawing on Location

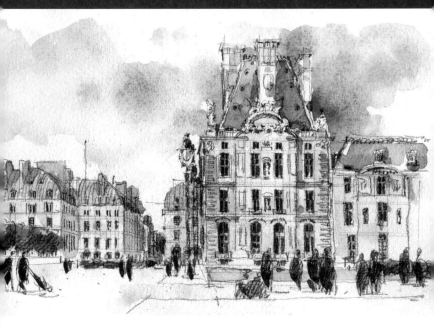

STEPHANIE BOWER

About This Series

The Urban Sketching Handbook series takes you to places around the globe through the eyes and art of urban sketchers.

Architecture and Cityscapes, People and Motion, Reportage and Documentary Drawing, and now *Understanding Perspective*—each book offers a bounty of lessons, tips, and techniques for sketching on location for anyone venturing to pick up a pencil and capture their world.

⟳ EVGENY BONDARENKO
Russia
Kowloon Walled City, Hong Kong
15.75" x 23.62" | 40 x 60 cm;
Ink pencil, ink on watercolor paper;
2.5–3 hours.
Two-point/worm's eye view.

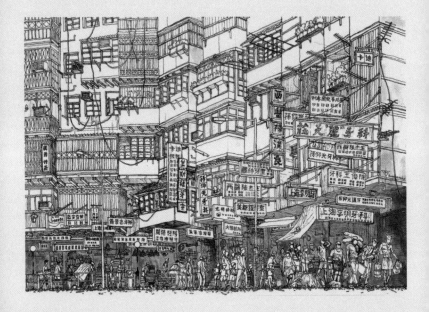

CONTENTS

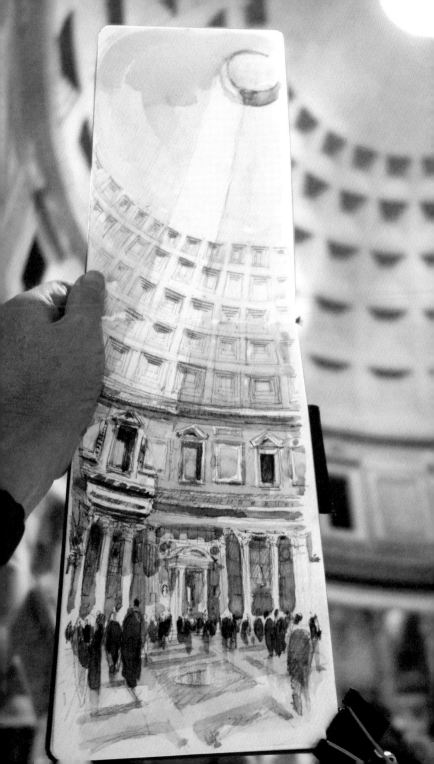

INTRODUCTION

Imagine you are standing in an amazing space, say the Pantheon in Rome. Snapping a quick photo like everyone else isn't enough—you want to somehow capture this experience, but your group is leaving in only half an hour. What do you do? SKETCH!

Sketching on location is powerful. You have to look at something really carefully to draw it. The process of drawing imprints what you see into your brain in such a way that years from now, the sounds of the people walking by, the scent of the rain, the feel of the warm air, and much more will all flood back when you look at your sketch. Urban Sketching is about capturing your experiences on paper, and more important, in your mind and heart. It's a great way to learn and remember.

That said, sketching on location can be challenging and overwhelming. Where do you start a sketch? How do you shrink the vast, busy scene in front of you onto your paper? How does perspective work? And where *is* that darn vanishing point? *Understanding Perspective* helps you bridge the theoretical world of perspective concepts with the real world of on-site sketching.

All good sketches start with good bones. Perspective is simply a set of rules "discovered" during the Italian Renaissance that allows us to translate what we see in our three-dimensional world onto a two-dimensional surface, such as a piece of paper or canvas. These principles provide us with a simple structure we can use to create the foundational lines in our sketches.

Perspective doesn't have to be frightening or something you avoid. Once you know some basics and a simple process, your sketches will be faster, easier, and more believable—and it will change the way you see the world, as you'll see perspective everywhere!

Best of all, when you leave Rome with sketchbook in hand, you'll be bringing a bit of the Pantheon with you...

◗ *Pantheon, Rome, Italy*

16" x 5" | 40.5 x 12.5 cm; Pencil,
watercolor, Pentalic Aqua Journal;
about 45 minutes.
One-point/eye-level view.

Even in this digital age, learning to sketch what you see is an extremely valuable skill, whether you're an architect, designer, or artist who draws from imagination, or someone who simply loves sketching over coffee at a neighborhood cafe. Thinking and drawing in perspective is powerful because it helps us understand spaces and places in the way we actually see and experience them.

This handbook provides the tools you need to create a believable sense of perspective in your sketches, no matter what style or media you use, by looking at a variety of work produced by different sketchers from around the globe. It also includes a lot of thumbnail diagrams to explain the perspective concepts featured in various sketches.

Tip

Try using a colored pencil to draw right over the thumbnails as a way to better understand the information.

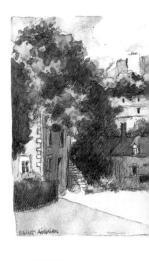

∩ **GUY MOLL**
France
Saint-Aignan

5" x 12" | 12.5 x 30.5 cm;
Ink, watercolor; about 1.5 hours.
One-point/eye-level view.

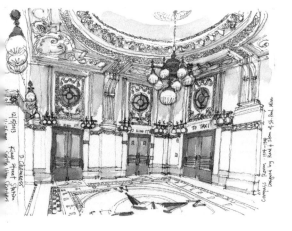

☾ **DAVID CHAMNESS**
USA

King Street Station:
Compass Room

11" x 14" | 28 x 35.5 cm;
Noodler's Black Ink, Winsor &
Newton watercolors, watercolor
paper; 2 hours.
Two-point/eye-level view.

We can learn so much by sketching the things we see. When sketching something like a castle in France or King Street Station in Seattle, it's like peering into the past through a time machine, into the minds of the people who created the building or space.

What did they want us to notice first? Why did they want five windows versus six? What draws your eye? And what do you want to capture in your sketch?

◍ JOSIAH HANCHETT
USA

Schooley's Mountain General Store

5" x 8.25" | 12.5 x 21 cm; Ink, watercolor; 3–4 hours. Two-point/eye-level view.

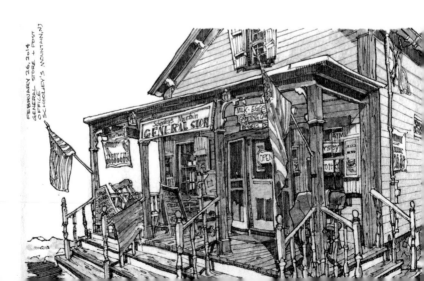

Sketching is also a great way to record the large and small events of daily life...wherever you are. Your kitchen, your neighborhood library, or your favorite coffee shop are all places where you can relax for an hour with a sketchbook.

Lots of sketchers talk about "being in the zone" when they work...the part of your brain that keeps track of time seems to shut off, and you are completely focused on seeing your subject and creating your sketch...interrupted only by the passersby who say, "Wow, great job. I wish I could do that!"

➲ Journalist, graphic artist, and Urban Sketchers founder Gabi Campanario uses sketching for visual note-taking and to report newspaper stories about the people and places where he lives.

GABRIEL CAMPANARIO
USA
Waterfront
5.5 " x 8" | 14 x 20.5 cm; Uni Ball Vision fine pen, watercolor; 30 minutes. One-point/eye-level view.

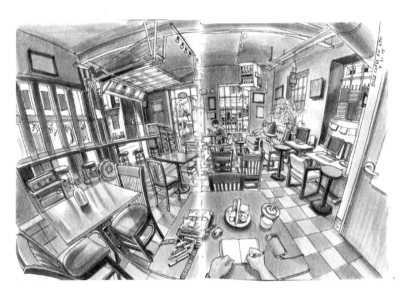

♠ Paul Heaston is a master of linework and amazing wide-angle perspective views. His subject is often his home, coffee shops, or streets where he lives. His sketches elevate the ordinary to the status of art. Paul frequently draws his own hands and sketchbook into the image, allowing us to essentially see what he sees.

PAUL HEASTON
USA
At Buzz Cafe
6" x 9" | 15 x 23 cm; Tombow Grayscale Markers, Staedtler Pigment Liners, Stillman & Birn Alpha paper in a handmade sketchbook; 2 hours. Two-point fish eye/eye-level view.

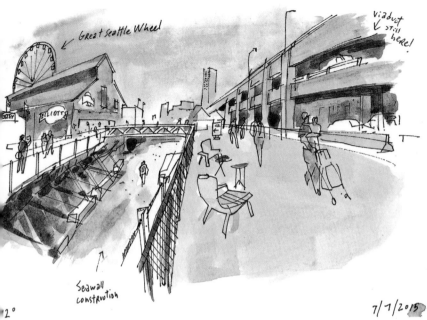

← Great Seattle Wheel

viaduct
↙ still
here!

ELLIOTT'S

Seawall
construction

2°

7/7/2015

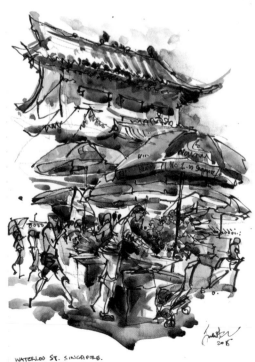

➲ Suhita Shirodkar does
amazing sketches of people
in action and chaos, with
a backdrop of accurate
perspective. Here she
captured a busy flower
market in Singapore.

SUHITA SHIRODKAR
USA

Waterloo Street, Singapore

12" x 8.5" | 30.5 x 21.5 cm;
Fountain pen, watercolor; about
30 minutes.
Two-point/eye-level view.

WATERLOO ST. SINGAPORE.

SKETCH HERE!

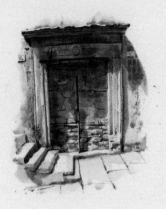

KEY I
BASICS

A few basic tools and concepts are the first keys to opening the door of *Understanding Perspective!*

Tools
Terms
Proportions and Measuring

"One of the primary motivations for drawing this scene was how the beautiful sunlight interacted with this unusual architectural remnant. More layers of ink were necessary to make the sunlight glow." – Fred Lynch

⌒ FRED LYNCH
USA
Bella Vista Doorway
12.5" x 9.5" | 31.5 x 24 cm; Winsor
& Newton brown ink, Arches Hot
Press Watercolor Block; 2 hours plus
1 hour in studio.
One-point/eye-level view.

TOOLS

Are you a pencil person or a pen person? Finding the right tools to express yourself is a great place to start your urban sketching adventure! For working on location, the name of the game is light, small, and portable. This handbook teaches concepts that will be useful for any sketching or painting media, but here are a few basic supplies that I carry.

I love the variety of line I can get in pencil, but lots of sketchers use pens, both felt tip and fountain pens. Experiment and find your favorite sketching tools.

Tools

☐ Mechanical pencil 0.5mm (so I don't have to carry a pencil sharpener) with B or 2B lead

☐ Small kneaded eraser

☐ Small straight edge or architect's triangle (for quickly snapping longer lines)

☐ 2 binder clips (for holding paper in place)

☐ Watercolor supplies, including small paint palette with watercolor travel brushes (I also sometimes use a portable easel)

☐ Sketchbook

☐ Plastic bags (to separate wet and dry supplies)

☐ Portable stool (It helps to be comfortable when you sketch on location)

☐ Backpack or other travel bag to carry and secure supplies

⌒ Sketching supplies need not cost a fortune! Visual journalist Richard Johnson uses the simplest of tools to do his amazing sketches, often just a ballpoint pen. Talk about light and portable!

RICHARD JOHNSON
USA
Junk Shelves in the Garage
8" x 10" | 20.5 x 25.5 cm;
Ballpoint pen, paper; 1.5 hours.
One-point/eye-level view.

Workshop

Like musicians who practice scales, sketchers can become better at making lines by practicing.

Try this exercise:

Fill a few pages with lines. They should be about ¼" (6 mm) apart and as straight as possible. Use any paper you have handy, the bigger the better. Wobbly lines are okay, but avoid making short hairy lines.

Observe how you make the straightest lines, is it better to work fast or slow?

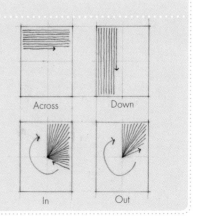

More and more sketchers are using digital media for their work. It's highly portable and easy to make changes!

As technology continues to improve, we'll see more variations in the types of sketches and methods used to create them.

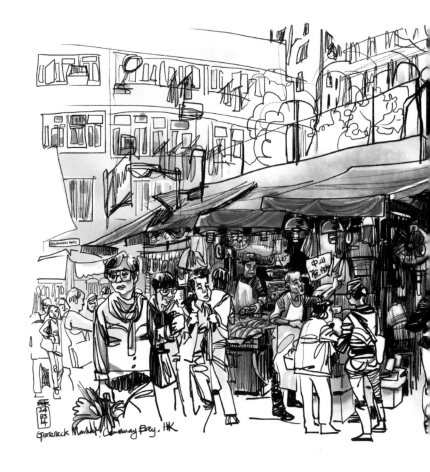

Gooseneck Market, Causeway Bay, HK

"Neighborhood markets in Hong Kong are often tucked away in little alleys or narrow streets, with shops on the ground level and residences towering above...

When I began, there weren't many shoppers, but it soon got busier. With increasing frequency, a fish would flap frantically as it was netted, showering me with an odorous mist. Urban sketchers stick it out however, and as I was already well into my sketch, was determined to see it through. The fishy smell took a few washes to truly leave my clothes, but I think the effort was worth it!"
– Rob Sketcherman

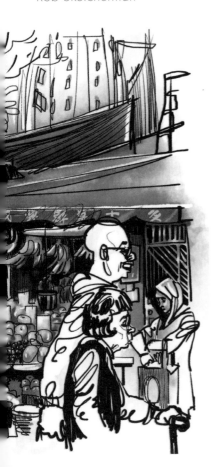

☞ ROB SKETCHERMAN
Hong Kong
Gooseneck Market Morning
*8.25" x 13.5" | 21.2 x 34 cm;
iPad Air, Procreate (app) and
pressure sensitive stylus: Wacom
Intuos Creative Stylus (1st gen
with modified nib); 1.5 hours on
location, finished later.
Two-point/eye-level view.*

TERMS

Architects use these terms all the time, and it is very helpful for perspective sketchers to understand this vocabulary as well.

Parallel

Lines, planes, and objects that are spaced an equal distance apart are *parallel*. Think of train track rails, the edges of a sidewalk or street, the lines that define windows and doors, or parallel courses of stone or brick in a wall.

Why is this important?

Even though we understand parallel lines to be equally spaced apart, we actually see parallel lines that recede away from us appear to intersect at one point off in the distance. This concept is important to the structure of a perspective sketch.

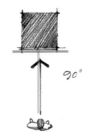

Perpendicular

A line that is at a 90-degree angle to another line, surface, or plane.

Why is this important?

It's often easiest to start a sketch with a view in which your line of sight is perpendicular to what you are drawing.

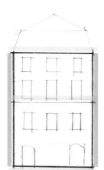

Elevation

A flat, frontal representation depicting one face of a building. To approximate seeing an *elevation*, your line of sight is perpendicular to the building face, looking straight ahead. The building's horizontal and vertical lines appear as true horizontal and vertical lines in your drawing.

Why is this important?

When sketching buildings and spaces, it is often easiest to start with the simple shapes in an elevation view.

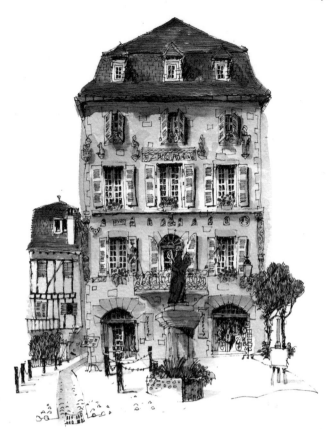

BEAULIEU

Elevation Sketch

Chris Lee's sketch of a building facade is an elevation view—he was sitting directly in front of this building and looking straight ahead with his line of sight perpendicular to the building face.

In elevation sketches, it's easy to simplify the shape of the building, which in this image is a tall rectangle. The edges of the building appear as true verticals, and horizontal lines such as the tops and bottoms of windows, the decorative molding, and front roofline appear as true horizontals. Look for these horizontals and verticals to identify an elevation view.

♎ **CHRIS LEE**
UK

Beaulieu-sur-Dordogne, France

11.67" x 8.3" | 29.64 x 21 cm; Pen, ink, watercolor; 1 hour. Elevation/eye-level view.

Elevation views are great for beginning sketchers. They are relatively simple to draw and are a good way to practice seeing accurate proportions. Each of these sketches started with basic squares and rectangles.

⮑ Looking directly at this brightly lit facade intensifies the feel of the blazing Spanish sun in Clark's sketch.

CLARK SMITH
USA
Early Renaissance Doors in Cáceres, Spain
9" x 6" | 15 x 23 cm; HB graphite in leadholder, paper; 5 minutes. Elevation/eye-level view.

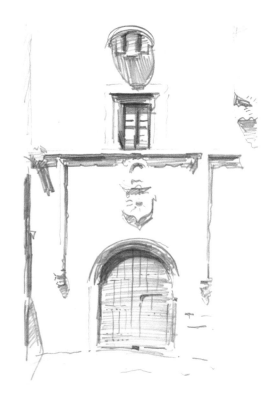

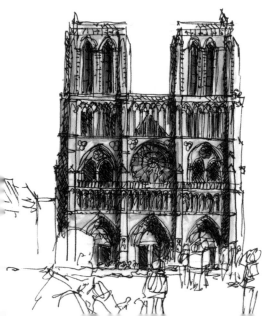

⮐ Liz's sketch of Notre-Dame Cathedral in Paris is a symphony of squares and rectangles in elevation.

LIZ STEEL
Australia
Notre-Dame
8.25" x 5.75" | 21 x 14.5 cm; Noodler's Bulletproof ink in Lamy pen, Winsor & Newton watercolor; 40 minutes. Elevation/eye-level view.

🎧 Find the simple rectangle that forms the foundation of Shari's watercolor sketch.

SHARI BLAUKOPF
Canada

Chocolatier Marlain

12" x 9" | 30.5 x 23 cm;
Watercolor; 1.5 hours.
Elevation/eye-level view.

Elevation sketches can be as simple or complex as you want to make them.

⮑ The face of the red building in Alfonso's sketch starts with a large horizontal rectangle. The line at the top of the rectangle, the line where the building hits the ground, and lines like the decorative molding on the face of the building are seen as horizontal lines, making this portion of his sketch an elevation view.

ALFONSO GARCÍA GARCÍA
Spain

Audience Building at San Francisco Square, Sevilla

8.25" x 11.5" | 21 x 29 cm;
Fineliner pen 0.05mm, watercolor;
1 hour.
Elevation/eye-level view.

⮑ This string of colorful trailers is seen primarily as a side, elevation view.

Georgetown Trailer Mall

5" x 16" | 12.5 x 40.5 cm;
Mechanical pencil, watercolor;
1 hour.
Elevation/eye-level view.

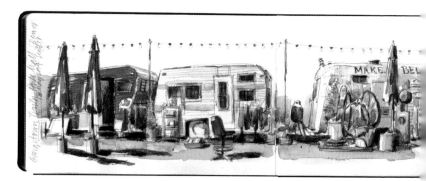

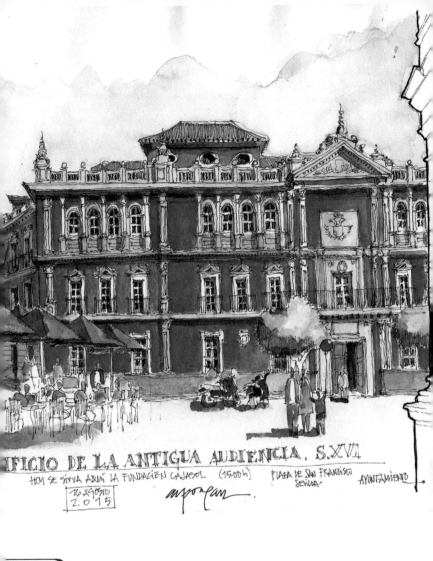

FICIO DE LA ANTIGUA AUDIENCIA, S.XVI

HOY SE SITUA AQUÍ LA FUNDACIÓN CAJASOL (15:00 h) PLAZA DE SAN FRANCISCO
 SEVILLA

16 AGOSTO
2015 AYUNTAMIENTO

Workshop

Try sketching a doorway or the facade of a building.
Start by drawing the big shapes as simple rectangles
and squares.

PROPORTIONS AND MEASURING

To make believable sketches, it's important to capture accurate shapes, and to draw accurate shapes, you need to see accurate proportions (imagine the refined architecture of the Taj Mahal looking too tall or too wide).

For sketchers, *proportions* are the relationship between the **height** and the **width** of an object, building, or space.

You can easily measure proportions in the field by following a few simple steps. First, learn to see buildings and spaces as simple shapes like squares, rectangles, and circles. These are easier to see if you flatten your view by closing one eye, as we need both eyes to perceive depth.

Next, use your pencil as a measuring stick to find the ratio of height to width of the object or space. I usually start by lining up my pencil with a vertical edge, then while keeping my arm locked at the same distance, I drop my pencil horizontally to compare this height to the width.

◑ Imagine you are in France at Versailles and want to sketch this window. Ignore the mullions and details, and just look for simple shapes—in this case, a tall rectangle.

Use your pencil to measure the height and width of this basic shape to determine its proportions.

If the window is one pencil tall, it measures half a pencil wide, giving you a proportion of 1:½.

Then transfer these proportions to your paper to start your sketch. It's not the actual height of your pencil that you are drawing on your paper, but the proportions of height to width that you observed and measured that will be reflected in your first few lines.

Tip

Notice how the windows in this view align vertically. It's helpful to look for architectural elements that relate to each other horizontally or vertically to make drawing easier. Try drawing this as light guidelines in your sketch.

⊃ Draw the Shape of the Face

Notice the horizontal lines on this building facade. This is an elevation view, as you are looking straight ahead.

Ignore any detail and just find basic shape or the **Shape of the Face** of this building in India.

To draw this facade accurately on location, start by using your pencil to measure the proportions of the height and the width.

The proportions here are approximately 1:1, or very close to a square. It's easy to transfer this shape to your paper and start your sketch.

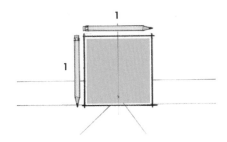

⊃ Draw the Shape of the Space

When drawing architectural spaces like this courtyard in Paris, it's helpful to see this shape as a simple box. Draw the **Shape of the Space** by starting with the back wall of the box as a rectangle.

The proportions here are approximately 1:2, or very close to two squares. This is the Shape of the Space that you transfer to your sketchbook.

Tip

When looking at proportions in architecture, look for squares! It's amazing how often you'll find the shape of a square in buildings and spaces.

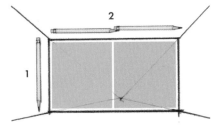

SKETCH HERE!

KEY II
BASIC SPATIAL PRINCIPLES

The basic principles of perspective are so familiar in our daily experiences of the world around us that we rarely give them much thought. Learning to clearly see and understand these concepts is an essential part of creating believable perspective sketches.

Diminishing
Converging
Foreshortening

⌂ SHARI BLAUKOPF
Canada
Left Leaning
8" x 8" | 20.5 x 20.5 cm;
Ink, watercolor, Hand Book
Watercolor Journal; 45 minutes.
One-point/eye-level view.

DIMINISHING

Think about a long line of telephone poles vanishing into the distance. In the world we see, objects of the same size and spacing appear smaller and closer together as they recede away from us. These changes are important for conveying a sense of depth in perspective sketches.

Remember: Things close to you look bigger; things far from you look smaller and closer together.

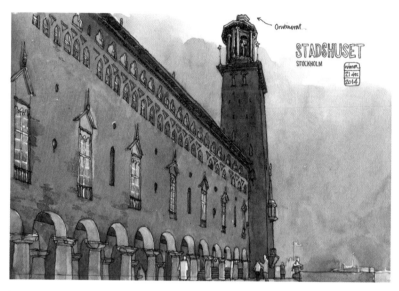

🎧 In Nina's sketch, the windows and arched openings appear gradually smaller and closer together as they recede away from her, giving a strong sense of perspective depth to the building.

NINA JOHANSSON
Sweden

City Hall (Stadshuset) in Stockholm

6" x 8.75" | 15 x 22 cm; Uni Pin Fineliner, watercolors, Stillman & Birn Alpha Series sketchbook; about 1.5 hours. One-point/eye-level view.

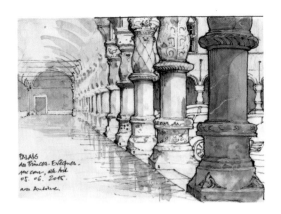

↻ Columns of the same size appear to get smaller and closer together as they recede away from the sketcher.

GÉRARD MICHEL
Belgium

Liège, Palace of the Prince-Bishops, First Courtyard

8.25" x 11.25" | 21 x 30 cm;
Pencil, watercolor, pigment liners,
A4 Seawhite sketchbook; 1.5 hours
One-point/eye-level view.

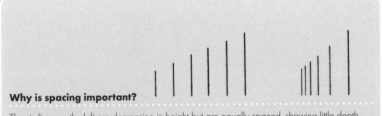

Why is spacing important?

The six lines on the left are decreasing in height but are equally spaced, showing little depth. The same lines on the right show both the height and spaces between the lines gradually decreasing. Changes in BOTH height and spacing are necessary to depict an accurate sense of depth in perspective.

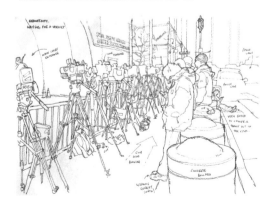

↻ The long line of cameras and tripods diminishing into the distance creates a strong sense of perspective depth in Richard Johnson's sketch.

RICHARD JOHNSON
USA

TV camera crews awaiting developments at Boston Marathon bomber trial

8" x 12" | 20.5 x 30.5 cm;
Ballpoint pen, Moleskine sketchbook; 30 minutes.
One-point/eye-level view.

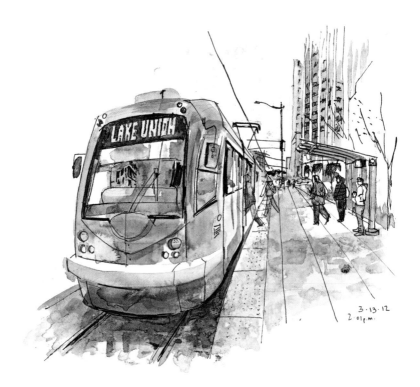

CONVERGING

Stand on a sidewalk and look down the street. We understand that a straight street is a consistent width and that the edges of the street are in fact lines that are parallel to each other. Although we know this in our brains, it is not what we see with our eyes!

Lines that are in reality parallel to each other (like the edges of sidewalks or streets, courses of brick or stone, the tops and bottoms of windows on a facade, etc.) appear to our eyes to recede away from us and intersect at one point off in the distance. The point where these lines converge is appropriately called the "vanishing point," often labeled "VP," and is usually at the height of your eye level above the ground.

Remember: Lines that are parallel to each other appear to converge to one point in the distance.

♩ Sidewalk joint lines, the street edge and yellow curb, and the top and bottom lines of the train in Gabi Campanario's sketch are all parallel to each other. In perspective, we see these lines converging to one point in the distance ... the VP at Gabi's eye level.

GABRIEL CAMPANARIO
USA

South Lake Union Streetcar
10" x 11" | 25.5 x 28 cm; Pencil, ink, watercolor, Canson Mixed spiral-bound sketchbook; about 1 hour.
One-point/eye-level view.

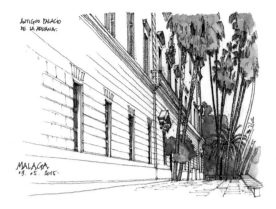

Tip

How do you find the point where lines converge? Close one eye and use your pencil to extend the receding lines you see until you find the point where these lines intersect. Then mentally "pin" that point on something in your view that you can reference while you sketch.

◑ The horizontal lines in the building facade, the lines of stone on the ground, even the bench, are parallel lines that appear to converge to one point in Gérard Michel's sketch.

GÉRARD MICHEL
Belgium

Málaga, Antiguo Palacio

8.25" x 11.5" | 21 x 29 cm; Pencil, liners, watercolor (Payne's Grey), Sketchbook A4 horizontal, Seawhite of Brighton; about 1 hour.
One-point/eye-level view.

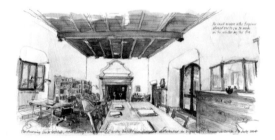

◖ In this sketch of a room interior, we see the walls on either side receding in space. If we extend the lines that are in reality parallel to each other, like the beams in the ceiling and the furniture, they all appear to intersect at one point directly in front of me at my eye level. This is the VP (orange dot) on my eye-level line (blue horizontal line).

The Civita Institute's Sala Grande

8" x 16" | 20.5 x 40.5 cm; Pencil, watercolor, Fluid watercolor paper; 45 minutes.
One-point/eye-level view.

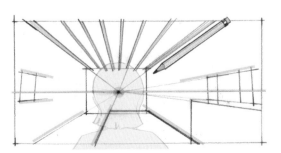

The mysterious Horizon Line ... what is it?

Think about a time when you were at the beach looking out at the ocean... did you ever notice that the line where the ocean meets that beautiful sunset in the distance was actually at your eye level?

The *horizon line* is literally the horizontal line where the earth meets the sky. The amazing thing about the horizon line is that it is **always at your eye level**, no matter where you are standing or looking.

Most of the time, however, the horizon line is hidden by buildings, mountains, trees, etc., so instead, it is much more useful for sketchers to think of this line as their *eye-level line*.

> ### Horizon Line, HL = Your Eye-level Line, EL
> (Yes, they are the same thing!)

As we've seen with the principle of convergence, most receding perspective lines intersect at points on your eye-level line. If you are standing, your eye level is around 5' (1.5 m) high for a person of average height. If you are sitting, your eye level and VPs are lower—about the height of a door handle. If you are on the thirtieth floor of a building, receding lines are converging to a point straight out in the distance that is at your eye level thirty floors up, and yes, even if you are up in a plane sketching buildings on the ground out your window, lines will converge at the horizon line at your eye level of 30,000' (9 km)!

How can I find my Eye-Level Line?

Hold out a pencil horizontally in front of your eyes. Don't tilt your head even the slightest bit up or down, just look straight ahead. Find something in your view where you can pin this horizontal line as a visual reference while you sketch.

TIP
It's a good idea to always draw your eye-level line lightly into your sketch for reference.

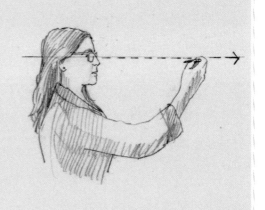

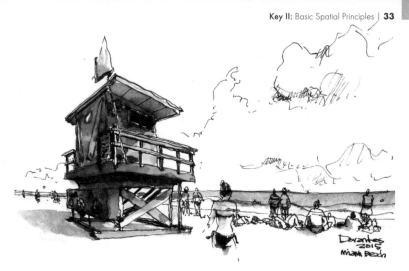

↻ Norberto's sketch at the beach offers a perfect explanation of the horizon and eye-level lines. If you extend the lines of the lifeguard station that are vanishing to the right and find where they intersect, they more or less converge to a point on the actual horizon (try it!). You can also see that the horizon line is the same as his eye-level line, the same as the eye level for other people standing on the beach.

In an eye-level view, if the ground is more or less flat and the people are roughly your height, their eye level will be the same as yours, whether they are standing close by or far away.

NORBERTO DORANTES
Argentina

Miami Beach

7.88" x 9.75" | 20 x 25 cm;
Non-waterproof ink, watercolor,
sketchbook for mixed media;
20 minutes.
Two-point/eye-level view.

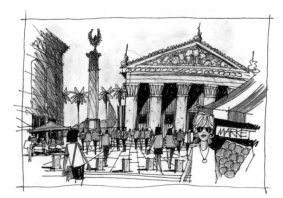

↻ In James Richards' eye-level sketch, everyone's head aligns at his eye level no matter where they are standing in the piazza.

JAMES RICHARDS
USA

Crowd in the Piazza

5.5" x 8" | 14 x 20.5 cm; Ink,
Prismacolor colored pencils, Canson
80lb. drawing paper; 20 minutes.
One-point/eye-level view.

FORESHORTENING

Place a book on a desk and look down at it. You can easily make out its rectangular shape and size from this view. Now hold the book directly in front of your eyes ... you can no longer see its shape or how big it is. We call this principle *foreshortening*.

For sketchers, foreshortening happens when lines and surfaces appear to flatten out as they get closer to your eye level or vanishing point. Foreshortening is an abstract concept, but it's useful in many aspects of sketching.

Remember: The closer something is to your eye level or vanishing point, the flatter it will appear.

↻ Tia Boon Sim's sketch shows foreshortening in two ways: The lines in the paving flatten out to a *vertical* line as they get closer to the vanishing point, and the windowsills flatten out to a *horizontal* line, indicating Tia's eye level was at that height.

TIA BOON SIM
Singapore

National Museum of Singapore

8.25" x 10.25" | 21 x 26 cm;
Hero fountain pen and ink,
Moleskine Japanese album large;
45 minutes.
One-point/eye-level view.

How can foreshortening help you find your eye level and vanishing point?

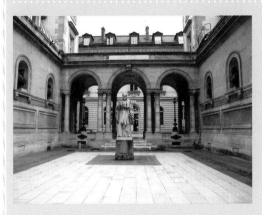

Foreshortened Lines

The building architecture can show you how to locate the eye-level line and vanishing point in your sketch. It helps to close one eye to flatten your view.

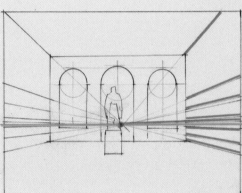

Horizontal Foreshortening

The angled lines of the molding on the side walls flatten to a horizontal line at your eye level. When sketching, look for architectural elements like courses of stone or brick to flatten at the eye level too.

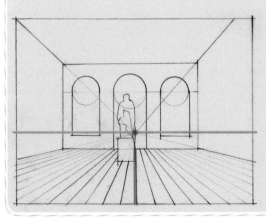

Vertical Foreshortening

The receding joint lines in the stone paving flatten out to a vertical line that points directly to the location of the vanishing point. It's often helpful to use lines in the paving or floor to help you locate your VP.

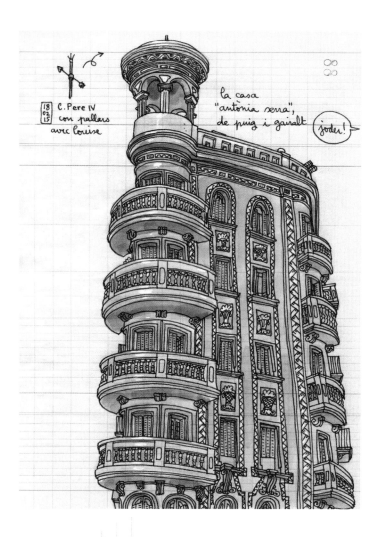

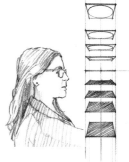

○ In perspective, we see the corner balconies of this building as a stack of foreshortened circles or ellipses. These ellipses appear flatter closest to Lapin's eye level just below the sketch and gradually get more and more rounded the higher above his eye level they appear.

LAPIN
Spain

Casa Antònia Serra

8.25" x 6" | 15 x 21 cm; Ink pen, watercolor, colored pencils, old accounting books; 1.5 hours. Two-point/worm's-eye view.

⊙ The wall on the right side of the street in Tia's sketch is close to her vanishing point and is therefore seen as flat and foreshortened. It tells us little about the doors and windows on that side of the street, while the left side that is further from her VP and less foreshortened shows us a lot of information.

TIA BOON SIM
Singapore

Norris Road at Little India, Singapore

*9.75" x 9.75" | 25 x 25 cm;
Hero fountain pen, ink, watercolor,
Daler Rowney watercolor paper;
1 hour.
One-point/eye-level view.*

Tip

Foreshortening is an important concept to consider when composing your views and determining the story your sketch will tell.

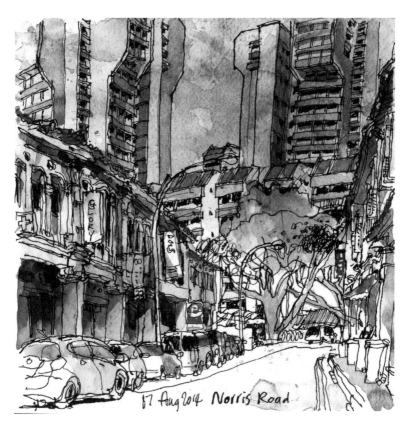

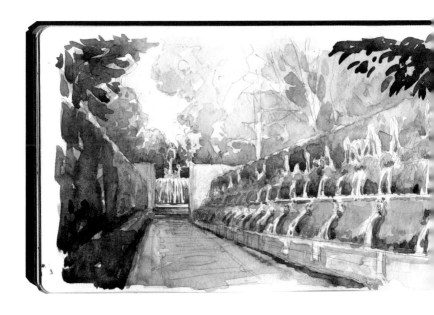

This late afternoon sketch of the Cento Fontane or One Hundred Fountains demonstrates many of the basic spatial principles of perspective.

Diminishing
Water spouts that are the same size and equally spaced appear to get smaller and closer together as they are seen farther away from me, the sketcher.

Converging
The stacked walls of the fountains are in reality parallel to each other in height, but they appear to converge at one point in the distance.

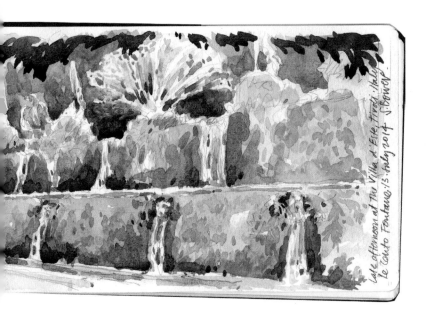

Foreshortening

The tops of the fountain walls appear to flatten as they get closer to my eye level. Note that the third from the top is nearly a true horizontal line, indicating this was close to the height of my eyes when I sat to do the sketch. Also, the green wall on the left looks flatter and more foreshortened than the wall with the fountains.

◑ *Cento Fontane,*
Villa D'Este, Italy

5" x 16" | 12.5 x 40.5 cm; Pencil,
watercolor, Pentalic Aqua Journal;
about 1 hour.
One-point/eye-level view.

SKETCH HERE!

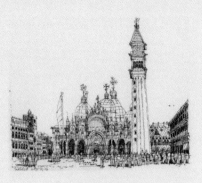

KEY III
TYPES OF PERSPECTIVES

Perspective literally means *point of view*. Whether sharing an idea or making a sketch from observation, your perspective is an expression of the way *you* see things.

In terms of drawing, formal linear perspective is a simple system that approximates your unique viewpoint of a three-dimensional world onto a two-dimensional surface. Describing types of perspectives involves two factors that are literally related to your view: the height of your eye level above the ground and the angle at which you are looking at your subject.

This key introduces the common types of perspective views and the characteristics that make each sketch an expression of your particular point of view.

VIEW EYE LEVELS
Eye Level
Aerial or Bird's-Eye Level
Worm's-Eye Level

VIEW ANGLES
One-Point Perspective
Two-Point Perspective
Multiple Vanishing Points

⋔ **LEE G. COPELAND, FAIA**
USA
Piazza San Marco, Venice
9" x 12" | 30.5 x 23 cm; Mont Blanc
fountain pen, ink, paper; 1 hour.
One-point/eye-level view.

VIEW EYE LEVELS

Are you in the middle of a busy New York sidewalk or looking down on the street from an upper floor? In general, perspective views are described as being one of three eye levels, each based on the height of your eye level above the ground.

Eye-Level View: eye level height of 3'-6' (.9 m-1.8 m), looking straight ahead

Aerial or Bird's-Eye View: high eye level, looking down on spaces and people

Worm's-Eye View: low eye level, looking up

Knowing your eye level is key to perspective sketching because the primary vanishing points for your sketch will usually be on your eye-level line, regardless of whether you are looking straight ahead, up, or down.

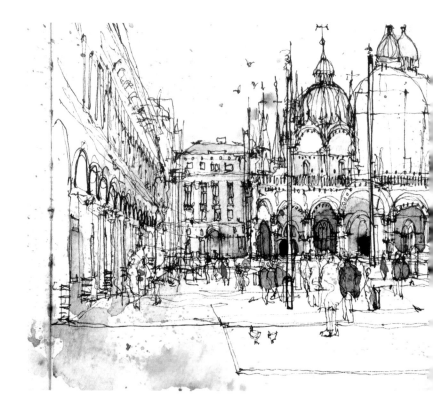

Eye-level view

The most common view for sketchers is what we call an *eye-level view* in which the sketcher is standing or sitting relatively near the ground and more or less looking straight ahead. This type of view is the closest to what we typically see and is great for showing a pedestrian experience.

An easy way to identify this type of view is to look at people's heads, as they will usually align with your standing eye level, as seen in Simone's sketch.

Tip

A common error in eye-level sketches is to put the vanishing point a little too high, in effect raising your eye level and "floating". Be sure your VP and EL are fairly low in these views. The lines on the ground are probably flatter than you think.

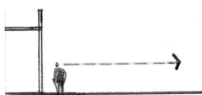

☛ SIMONE RIDYARD
UK
St Mark's Square, Venice, an urban sketch

5.5" x 8" | 14 x 20.5 cm;
Fineliner pen, watercolor,
A5 Moleskine; 1 hour.
One-point/eye-level view.

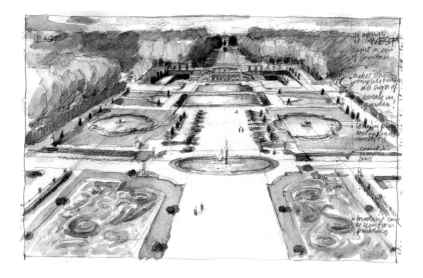

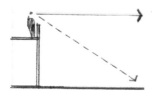
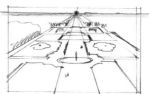

Aerial or Bird's-eye view

A bird's-eye view is when most of our subject is below us, as if we were birds aloft. Even though it feels as if we are looking down, the eye-level line and VP are in fact straight out at the sketcher's eye level, seen near the top of this sketch.

Aerial views are great for showing what is happening on the ground plane and for conveying a sense of distance. Notice how in aerial perspectives, people's heads do not align as they do in an eye-level view.

🎧 *Gabriel Prize study of the gardens at Château Vaux-le-Vicomte, France*

5" x 8" | 12.5 x 20.5 cm; Pencil, watercolor, Pentalic Aqua Journal; about 30 minutes. One-point/aerial view.

"To get this view of Vaux's famous garden, I had to climb the stairs through the dome and out onto the cupola balcony."
– Stephanie Bower

Worm's-eye view

A worm's-eye view is when we are primarily looking up. In his sketch, Luis' eye-level and VP are low, close to the ground. In worm's-eye views, vertical building lines are often seen as angled, similar to what happens when you tilt a camera up.

These types of views are dramatic and convey a sense of exaggerated height and upward movement. In a typical worm's-eye view, people's heads are seen above the sketcher's eye level.

◑ LUIS RUIZ
Spain
Church of Santiago, Málaga
8.25" x 11.75" | 21 x 29.7 cm;
Ink, watercolor; 1 hour.
Two-point/worm's-eye view.

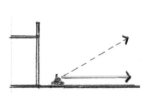

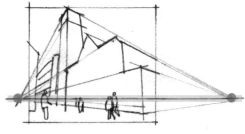

VIEW ANGLES

Where you are standing and looking impacts the type of perspective drawing you create. We describe the viewing angles primarily by whether the viewer/ sketcher is looking straight on at their subject or viewing their subject obliquely at an angle. A straight-on view will usually have one vanishing point, while the angled view will typically generate two vanishing points.

What is the difference between a one-point perspective and a two-point perspective?

It's where you stand relative to what you are sketching!

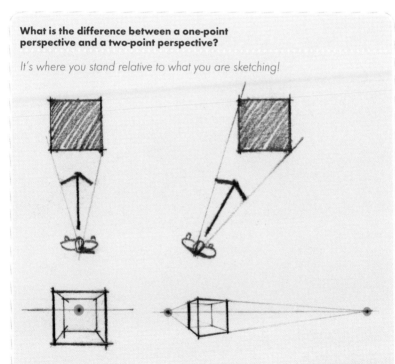

In a one-point perspective, you are looking straight ahead at an elevation view, with your line of sight perpendicular to the face of the building or space.

In a two-point perspective, you have walked to one side and are viewing your subject at an angle. Because one corner of the building is now closer to you, it appears bigger. Additionally, you can now see at least two sides of the building or space.

Each side has its own set of parallel lines that will generate their own vanishing point, producing two vanishing points. In a two-point perspective, you'll have one VP on the left and a second VP on the right, with BOTH on your eye-level line!

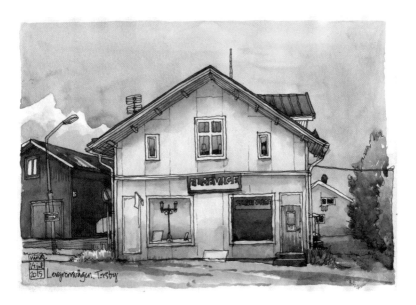

↻ Nina is looking perpendicularly at the face of this house and sees an elevation view, generating a one-point, eye-level perspective sketch. We can see bits of perspective in the receding roof edges and rafters tails. The location of the VP is directly in front of her, at her eye level.

NINA JOHANSSON
Sweden

Shop in Torsby, Värmland, Sweden

6" x 8.25" | 15 x 21 cm;
Ink fineliner pens, watercolors,
Stillman & Birn Alpha Series
sketchbook; 1.75 hours.
One-point/eye-level view.

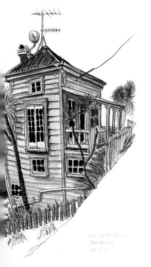

↻ In another small house sketch, Murray Dewhurst is viewing the building at an angle. The left side of the house will generate a VP on the left, while the right side will generate a VP to the right. Both VPs are on his horizontal eye-level line.

MURRAY DEWHURST
New Zealand

126 John Street, Ponsonby, Auckland

8.25" x 5.88" | 21 x 14.8 cm;
Pencil, Winsor & Newton watercolor,
Pentel brush pen, Hahnemühle A5
sketchbook; 45 minutes.
Two-point/eye-level view.

One-point perspective

In each of these sketches, we are looking perpendiculary at the building face and seeing the primary walls in elevation. Extend the lines that are receding away from you to find the single point where they converge. In these one-point perspective sketches, the vanishing point is directly in front of the sketcher.

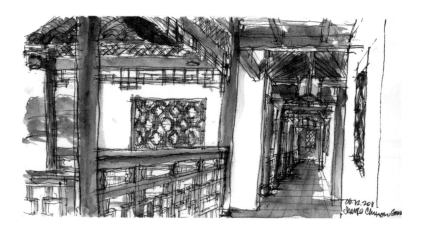

⋒ Notice how the top of the handrail is foreshortened to a horizontal line, indicating the height of Gail's eye level. (She must have been sitting!) All lines that are parallel to each other are converging at the VP down the hall, at her eye level.

GAIL WONG
USA

Seattle Chinese Garden Pavilion

*6" x 12" | 15 x 30.5 cm;
Hero bent nib pen with Noodler's
Bulletproof black ink on
acid-free Fluid watercolor block,
watercolor; 1 hour.
One-point/eye-level view.*

*Bavorn Niwet Temple,
Bangkok, Thailand*

*7" x 4.5" | 18 x 11.4 cm; Pencil,
watercolor, Fluid watercolor block;
about 20 minutes.
One-point/eye-level view.*

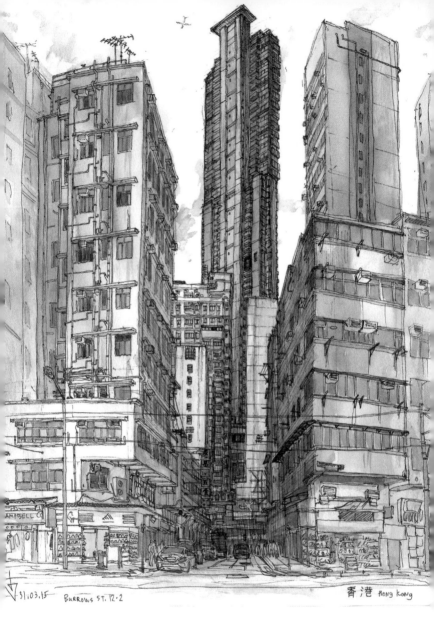

31.03.15 BURROWS ST. 12·2

香港 Hong Kong

O The front faces of the buildings in Evgeny's sketch are seen in elevation as he looks straight down this Hong Kong street. This view angle creates a one-point, eye-level perspective.

The horizontal lines at the top of the buildings angle down a bit to exaggerate the sense of height and distance. The tower in the background is rotated, so it generates its own VPs.

EVGENY BONDARENKO
Russia

Hong Kong Burrows Street

15.75" x 11.75" | 40 x 30 cm;
Liner (ink pen), watercolor;
4.5 hours standing.
One-point/eye-level view.

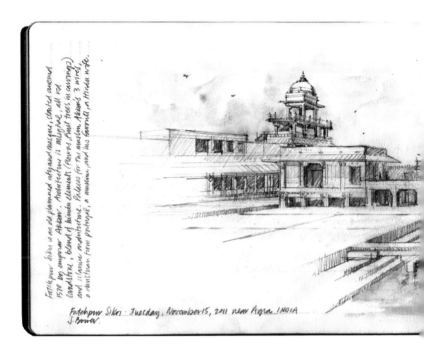

One-point perspectives can be powerful and dramatic, as the single VP pulls the viewer's eye into the sketch, through the space, and to the vanishing point. When the VP is centered, these views are great for showing formal, classical, or symmetrical elements in architecture.

Best of all, these views are relatively simple to draw, in fact nearly all my sketches are variations of one-point perspectives!

♠ *Fatehpur Sikri near Agra, India*
8" x 23" | 20.5 x 58.5 cm; Pencil, watercolor, large Moleskine sketchbook; about 45 minutes. One-point/aerial view.

Tip

Always draw a horizontal line at your eye level in your sketch! It is a useful reference line.

Lines ABOVE your eye level will tend to angle DOWN, while lines BELOW your eye level will tend to angle UP.

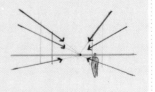

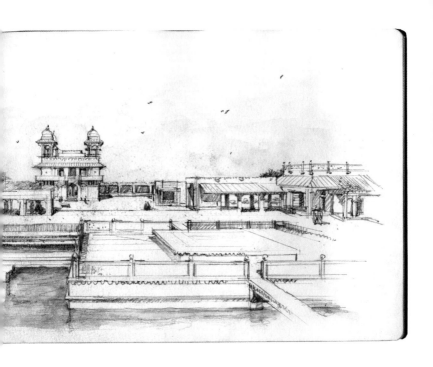

⮑ Eduardo's aerial sketch of a busy city avenue is made even more dramatic by having one vanishing point that pulls the viewer into the space and down the street.

EDUARDO BAJZEK
Brazil

Paulista Avenue

*12" x 8.5" | 30.5 x 20.5 cm;
Ink, markers; 1.5 hours.
One-point/aerial view.*

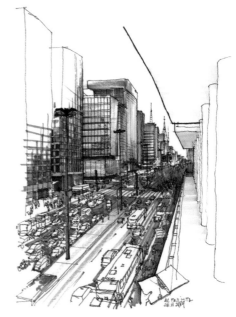

Two-point perspective

In each of these images, the sketcher is seeing the subject at an angle instead of straight on, so we see at least two sides of these buildings. Extend the converging lines on each side and you'll find the VPs left and right, both on the horizontal eye-level line of the sketcher.

Often in these views, at least one if not both vanishing points will be off your page, making these views a little more challenging to draw.

↻ EDUARDO BAJZEK
Brazil
Oscar Americano Residence
8" x 11" | 20.5 x 28 cm;
Watercolor; 40 minutes.
Two-point/eye-level view.

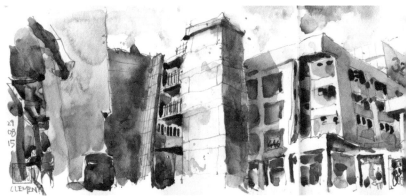

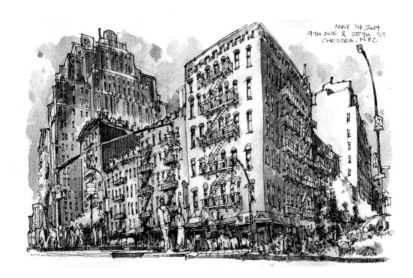

Josiah builds up a great texture of windows and New York City building details, with all these elements vanishing to two VPs at his eye level.

JOSIAH HANCHETT
USA

9th Ave & 25th St. Chelsea, NYC

5" x 8.25" | 13 x 21 cm; Ink, watercolor, large Moleskine sketchbook; 3 hours. Two-point/eye-level view.

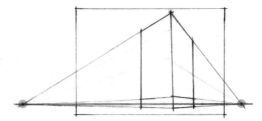

Paul uses lots of color and splashes to create a sense of vibrant activity in his sketch, held together with foundational lines that have a clear sense of architecture in two-point perspective.

PAUL WANG
Singapore

Saturday Morning at Clementi Central, Singapore

5.25" x 16.25" | 13 x 41 cm; Pencil, watercolor, Moleskine sketchbook; 45 minutes. Two-point/eye-level view.

Tip

Try to place the closest vertical edge off-center to create a composition with better movement. Placing that corner in the middle of your drawing splits the image in half and leads the viewer's eye out of your sketch.

MARC TARO HOLMES
Canada

Maison Smith, Montreal

⋒ *11" x 30" | 28 x 76 cm
(2@11x15, double page spread);
Watercolor; 30 minutes.
Two-point/eye-level view.*

⋒ Marc's painting of a house is almost a frontal view. The left VP can be found in his sketch, while the right VP is way off his page.

Don't be tricked when the ground plane rises or falls! The eye-level line and VPs are still at the height of your eyes looking straight ahead and are actually below the ground in both these sketches.

Tip

When you are sketching in the field, it can be difficult to figure out where your vanishing points are in a two-point perspective.

Try holding out your arms parallel to the walls of the building you are sketching...each hand will point to a vanishing point left and right. Make sure your arms point straight out at your eye level. Don't tilt up or down!

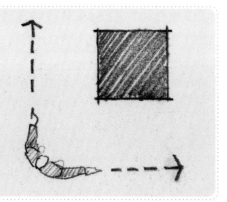

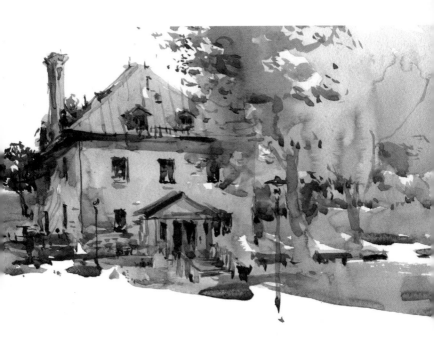

⮑ Even though he is looking up at the building, notice how David's eye level and VPs are below the ground in his sketch.

DAVID CHAMNESS
USA

Camp Casey,
Colonel's House

11" x 14" | 28 x 35.5 cm;
Pencil, Micron 08 ink pen, Koi
watercolors, watercolor paper;
2 hours.
Two-point/worm's-eye view.

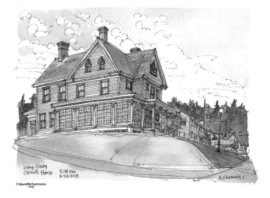

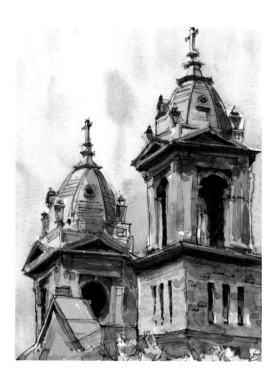

⟲ **SHARI BLAUKOPF**
Canada
Condo Church

12" x 9" | 30.5 x 23 cm;
Pen, watercolor; 1 hour.
Two-point/worm's-eye view.

⟳ **JAMES AKERS**
USA
Chautauqua Grange

4.5" x 7" | 11.5 x 18 cm;
Pilot Razor Point felt tip pen,
bond paper; 2 hours.
Two-point/eye-level view.

Tip

Shari's sketch of two cupolas focuses on the decorative tops of the church towers. Here, as is often the case with two-point perspectives, the VPs don't fit onto her paper.

What do you do if the VPs are off your page?

Close one eye and measure the angles with your pencil, then transfer that angle directly to your sketch.

It's helpful to remember that the closer the lines are to your eye level, the flatter they will appear.

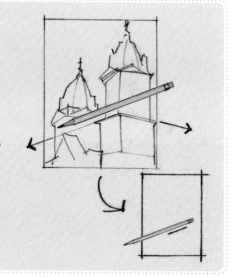

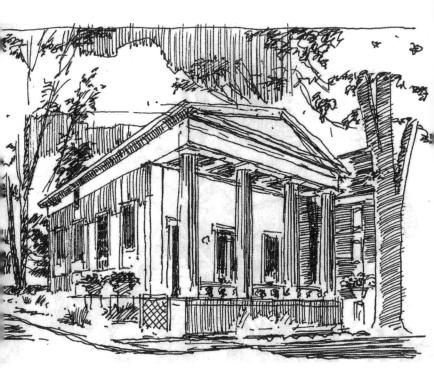

Tip

Jamies' sketch shows a pitched roof with a peak that is centered over the front face of the building.

How do you locate the roof peak accurately in perspective?

By finding the centerline of the wall and projecting that line up.

Think back to your high school geometry class and use diagonals! Lightly draw lines in your sketch that go from opposite corners. Where these lines cross is the centerline of the building face, both vertically and horizontally. Remember this trick, as you'll discover many situations in which it's helpful to use diagonals to find the center of a wall in perspective.

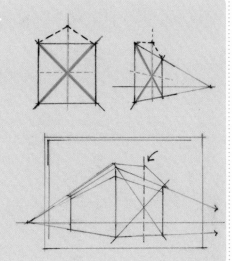

MULTIPLE VANISHING POINTS

While most perspective sketches are either one- or two-point views, there are some conditions in which additional vanishing points are generated. These new VPs usually relate to where you are looking, or when surfaces tilt either horizontally or vertically.

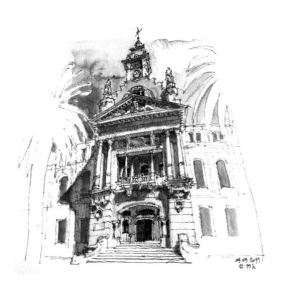

Looking up

Luis Ruiz creates a strong sense of height by drawing the building's vertical lines angling up to a third vanishing point in the sky. This third VP is often seen in worm's-eye views.

Notice how lines directly below the additional VP appear as a true vertical. This centerline is a useful reference, as lines to the right of center angle in one direction and lines on the other side of center angle the other direction.

Tip

If the VP doesn't fit on your page, determine your vertical centerline, shown in orange, and just use your pencil to measure other angled lines.

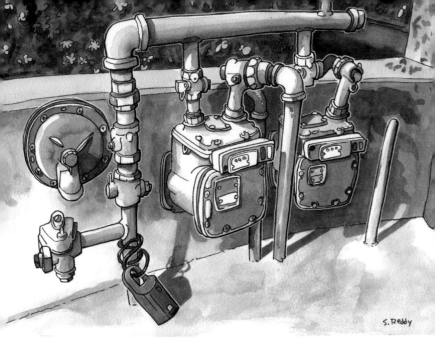

⌒ STEVEN REDDY
USA
Pipes
8" x 11" | 20.5 x 28 cm;
Pen, watercolor; 1.5 - 2 hours.
Three-point/aerial view.

Looking down

Steven Reddy creates a sense of looking down
by drawing the vertical lines in his sketch angling
down to a third vanishing point below the ground.
This additional VP is often seen in aerial views.

*"I passed by these pipes on my walk
home from work each day. I carry a small
folding stool with my minimal materials in
a satchel."* — Steven Reddy

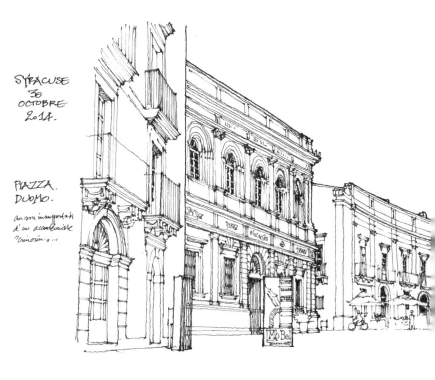

SYRACUSE
30
OCTOBRE
2014.

PIAZZA.
DUOMO.

au son inaspettati
d' un accademiste
"Crinolin q ...

Rotated buildings, horizontal rotation of surfaces

The perspective principle of convergence reminds us that every set of parallel lines will generate its own vanishing point.

Gérard's beautifully detailed piazza sketch shows a series of building faces that are not parallel to each other, so each facade generates its own VP!

When buildings are rotated or skewed in plan, as they often are in older cities that were not built on a grid, you will likely find multiple vanishing points along your eye-level line. Think of this as surfaces that are sort of twisting horizontally to remember that the VPs move along your eye-level line.

Remember: When buildings are skewed or rotated in plan, their vanishing points will shift left or right horizontally along your eye-level line.

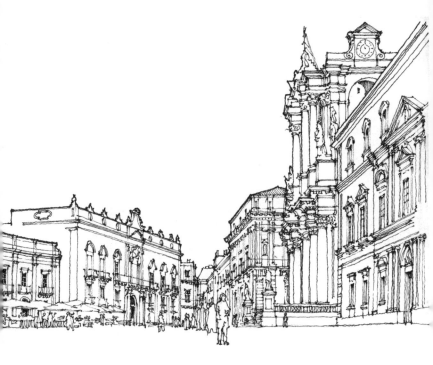

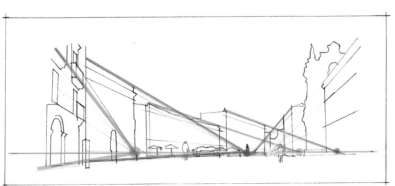

⋔ GÉRARD MICHEL
Belgium
Siracusa, Piazza del Duomo
8.25" x 19.5" | 21 x 49.4 cm;
Pigment liners; about 3 hours.
Multiple VPs/eye-level view.

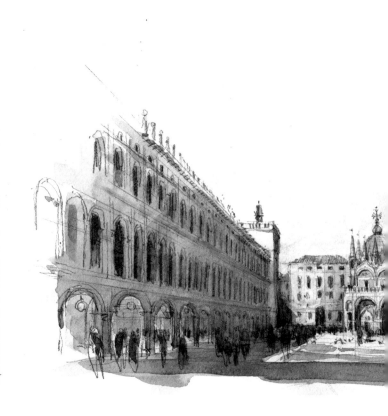

Afternoon in the Piazza San Marco · 21 June 2015 with Alain Jean-S Brooke.

Part of the charm of winding French streets and Italian piazzas is that they were not built on a modern square grid plan. When sketching these spaces in the field, use your pencil to extend the converging lines of each building facade to find its vanishing point. Remember that for most buildings, these VPs should all be on your eye-level line.

Workshop

Set up a few tissue or cereal boxes on a tabletop so that the faces are not parallel to each other. Use your pencil to find the VPs and notice how the VPs shift left or right along your eye-level line in your sketch.

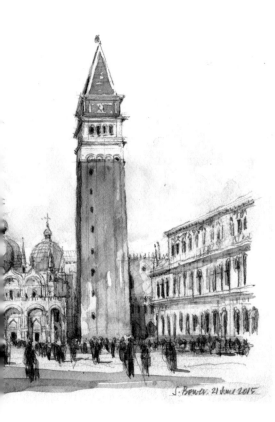

◖ *Piazza San Marco, Italy*

8" x 16" | 20.5 x 40.5 cm;
Pencil, Fluid watercolor block;
about 1 hour.
Multiple VPs/eye-level view.

◑ JÉRÉMY SOHEYLIAN
France
La Rue Amiral Roussin à Dijon

9.75" x 7" | 25 x 18 cm;
Black ink, watercolor, 1.25 hours.
Multiple VPs/eye-level view.

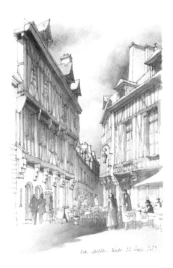

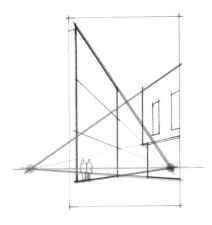

Tilted planes, vertical rotation of surfaces
Stairs, Ramps, Roofs, and Streets

We've seen that when buildings are skewed or rotated horizontally, their vanishing points also shift left or right horizontally along your eye-level line.

What about surfaces that rotate in the *vertical* direction? Planes that tilt up or down, like stairs, ramps, and roofs, also generate their own VP. Because these surfaces slant up or down vertically, the VPs will shift *up* or *down* vertically as well. The steeper the slope, the higher the vanishing point.

Notice that these additional VPs are usually directly over the primary VPs located on your eye level!

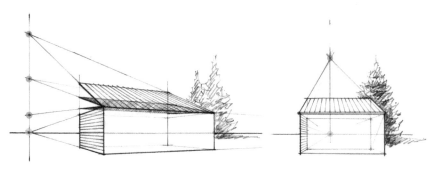

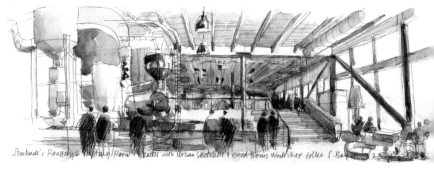

Starbuck's Roastery Tasting Room Seattle with Urban Sketchers + Good Bones Workshop folks S. Barry 2...

♁ Knowing that your VP *UP* is usually directly over the primary eye-level VP makes drawing sloped surfaces much easier! Think about stairs as a single tilted surface or ramp to find the VP of the slope (in orange). Draw a light guideline up from the primary VP, then measure the slope with your pencil to find the VP up along that light guideline. You can then use the horizontal VP (in blue) to draw the stair treads and a vertical line to represent the risers.

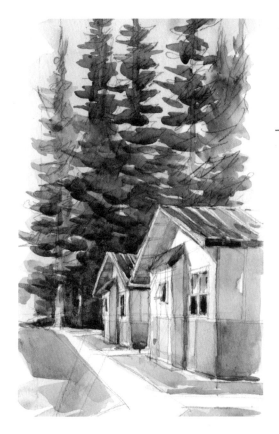

↻ In this sketch of Samish Island cabins, we see that the buildings on the ground have a primary set of VPs on the eye-level line. We also see that the sloped roofs generate additional VPs both up and down.

The surfaces that slope up and away from you generate a vanishing point UP. The backsides of each roof slope down and away from you, so they generate a vanishing point DOWN. If you look closely, you can see the light lines to these VPs in the sketch. All the seams in the roof go to these VPs too, the same as if you are drawing tile roofs in Spain or Italy!

Because both sides of the roof have the same slope, the distance to my VP up is equal to the distance to my VP down, with the eye-level line centered in the middle.

Samish Island Cabins

8" x 6" | 20.5 x 15 cm;
Mechanical pencil, watercolor,
Fluid watercolor block; 30 minutes.
One-point/eye-level view.

↻ *Seattle Starbucks Roastery*

6" x 18" | 15 x 45.5 cm;
Mechanical pencil, watercolor,
Fluid watercolor block; 45 minutes.
One-point/eye-level view.

View of "Green Carpet" toward Grand Canal 14 June 2013, VP S

♠ Gabriel Prize study of the Gardens at Versailles

5" x 16" | 12.5 x 40.5 cm; Pentalic Aqua Journal sketchbook, mechanical pencil, watercolor; about 30 minutes. One-point/aerial view.

"At the Gardens of Versailles outside of Paris, seventeenth century landscape architect André Le Nôtre used his knowledge of perspective to play tricks on the viewer of his famous gardens.

In this important view along the main axis, the water in the distance appears to be tilting up when in fact, Le Nôtre has sloped the ground plane in front DOWN. The edges of the sloping lawn in the foreground converge at a vanishing point directly below the VP for the grounds and pool, cleverly drawing the viewer's eye precisely to the statue of Apollo, the symbol for Louis XIV.

In doing this sketch, I discovered it's possible to peer into the mind of this amazing landscape architect who lived nearly 400 years before my time." – Stephanie Bower

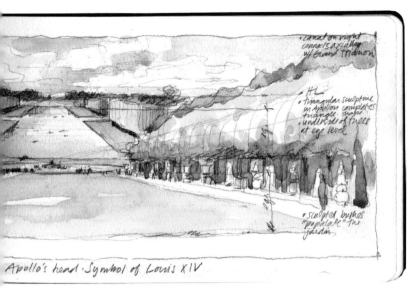

Apollo's head · Symbol of Louis XIV

➲ In Alan Maskin's line sketch of an Italian staircase, each change in angle will have its own vanishing point!

ALAN MASKIN
USA
Stair Todi

8" x 9" | 20.5 x 23 cm;
Ink, paper; 20 minutes.
Multiple VPs/eye-level view.

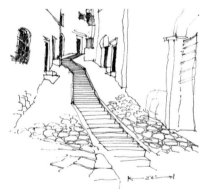

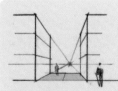

Flat, no slope

Usually, the up/down VP is directly above or below the primary VPs on your eye-level line!

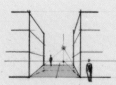

Sloping up

When the surface slopes UP and away from you, the VP is UP.

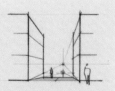

Sloping down

When the surface slopes DOWN and away from you, the VP is DOWN.

SKETCH HERE!

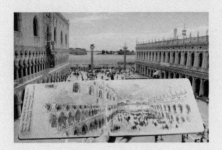

KEY IV
BUILD A SKETCH
IN LAYERS

All the concepts come together into simple recipes for sketching perspectives on location. By knowing what to look for, reducing your view to a few simple shapes, and building your sketch in layers, this step-by-step process demystifies perspective sketching. You'll never fear perspective again!

Shape of the Face
Shape of the Space
Shape of the Box

🎧 *Basilica San Marco, Venice*

5" x 16" | 12.5 x 40.5 cm; Pentalic
Aqua Journal sketchbook;
about 45 minutes.
One-point/aerial view.

BUILD A SKETCH IN LAYERS

You are sitting at a table with a coffee; it could be in your hometown or in the Piazza San Marco in Venice. Sketchbook in hand, you are ready to capture the scene. What comes next? With all the basic principles of perspective in your tool kit, it's time to apply this knowledge to create a sketch on location!

There could be twenty sketchers sitting in the same spot, sketching the same subject, and you'd get twenty completely different sketches! Everyone sees the world a little differently, and everyone's drawing hand is unique, which is part of the beauty in sketching your own personal story. There is no right or wrong. Each sketcher will have their own method for how to create an image, but my focus is on sketching architecture in perspective. Most of us with that goal have a pretty similar process, the gist of which is described in this chapter.

First, walk around a bit and pick a spot to sketch. What do you look for? Find a subject that interests you, something you want to learn more about or capture. I try to find a scene that has a clear sense of simple perspective. For beginners that could be a doorway or a building elevation; for advanced sketchers, it could be a busy street, a market, or a complex of buildings.

Most of my own sketches are variations of one-point perspective. If you are sketching a one-point view, make sure you are sitting or standing so that your

line of sight is perpendicular to the building or space, and when you are finding your vanishing points and eye-level line, don't tilt your head up or down (note the back of the head to show the sketcher's line of sight in many of the thumbnails in this handbook)—the VPs are at your eye level above the ground plane. And get comfortable. Carry a small stool if you prefer to sit, as it's hard to sketch when your foot is falling asleep.

Next, frame your view. Decide how much you want to include in your sketch. You can buy or make a little framing device, or do what I do and just use my hands to get a rough idea of composition. Is your sketch mostly horizontal or vertical?

Next, take a moment to study the scene. Ignore the details, and reduce what you see to simple shapes. Notice where your eye level is and find your vanishing points, and then mentally pin them to a line or object in your view. Decide what building edge or shape is a good place to start your sketch (more on this in the next few pages).

⟲ This sketch was never finished, as it started to rain, but it's great for seeing how I start a sketch by first blocking out the basic shapes.

Basic Shapes, Gabriel Prize study of Fontainebleau

5" x 16" | 12.5 x 40.5 cm; Pentalic Aqua Journal sketchbook. mechanical pencil; about 15 minutes. One-point/eye-level view.

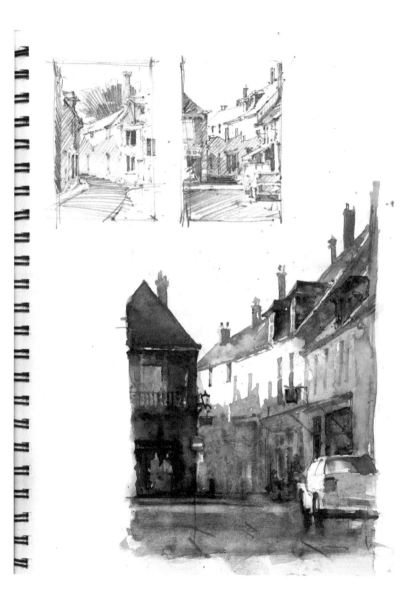

Artist and architect Bill Hook carries a sketchbook for making quick thumbnails when something catches his eye. He uses these as studies for larger paintings.

BILL HOOK
USA

France, Painting Studies
12" x 9" | 30.5 x 23 cm;
Pencil, watercolor; about 1 hour.
One-point/eye-level views.

Next, make a thumbnail sketch. This is a small drawing about the size of a large postage stamp. Don't include detail, just shapes and maybe some tone. I do these in the back of my sketchbook to quickly figure out the basic perspective and composition of my sketch in only a minute or two.

Now, it's on to your drawing. It's important to establish the size and content of your entire sketch in the first few minutes. Simplify your subject and quickly block out all the basic shapes using light *construction lines*. If you need to adjust the size or composition, erase now and start over before you invest a lot of time in your drawing. It's terrible to be 30 minutes into your sketch only to discover the top of the building doesn't fit on the paper!

Build your sketch in layers. By adding information in layers, big shapes are broken into smaller shapes with final layers of detail and color. The next few sections outline a sort of recipe I've developed for this process. The Shape of the Face, Shape of the Space, and Shape of the Box will provide you with a simple approach to creating the accurate foundational lines of almost any perspective sketch, in only three easy steps.

Finally, don't worry... about getting things perfectly accurate, as perspective only needs to be believable. Simply knowing these concepts will already help you to draw a better sketch. Remember, good cooks don't always follow the recipe as written. Enjoy the process, and with practice, you'll become your own cook and write your own recipes.

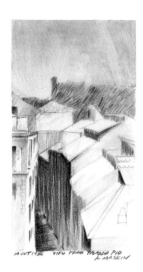

➲ You can ignore the detail altogether! Seattle Architect Alan Maskin does amazing sketches as part of his design process, but he learned this skill making observation drawings. In this sketch, he added one wash of simple color for glow and sketched the building forms over the wash to give the sense of the street as a valley.

ALAN MASKIN
USA
Aerial

12" x 9" | 30.5 x 23 cm; Pencil, watercolor; about 20 minutes. Multiple VPs/aerial view.

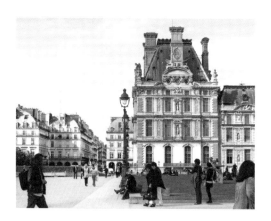

SHAPE OF THE FACE
A One-Point, Eye-Level Perspective

What to look for
Picking a spot to sketch is important. In this one-point, eye-level view, I've found a place where I can see this building in the Tuileries of Paris as a straight on, elevation view. My line of sight is just to the left of the building.

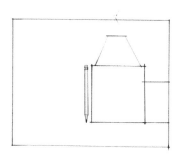

1. DRAW BASIC SHAPES
Reduce what you see to simple shapes. Use your pencil to measure proportions of height to width, then transfer this shape onto your paper using light lines. Erase and redraw if needed to make sure everything fits on the page.

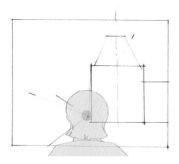

2. FIND THE VANISHING POINT
Use your pencil to extend receding lines to find the point where they intersect directly in front of you. "Pin" that point mentally in your view, and mark it on your drawing.

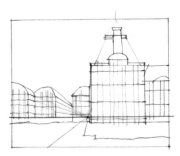

3. DRAW YOUR EYE-LEVEL LINE

For useful reference, draw your EL line horizontally across your sketch and through the vanishing point. Receding lines above it angle down to the VP, lines below it angle up.

Now you have all you need to draw accurate lines in perspective!

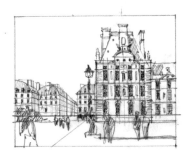

4. BREAK BIG SHAPES INTO SMALLER SHAPES

Layering in more information, add the major horizontal and vertical lines in the building faces. Draw the shapes of other buildings using the VP for receding lines.

5. ADD DETAIL AND TONE

Suggest building detail and a sense of materials. Darken lines as needed. Add people for scale, heads aligned along the eye-level line.

6. ADD COLOR

Finish the sketch with layers of watercolor, leaving lots of white paper for sparkle. Add spots of bright colors near the VP to draw the eye and suggest activity.

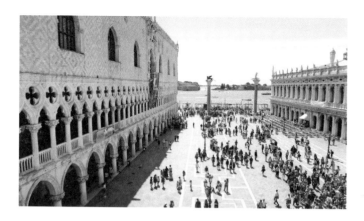

SHAPE OF THE SPACE
A One-Point, Aerial Perspective

What to look for

Looking out from the rooftop loggia of the Basilica San Marco in Venice, Italy, this is actually a simple space to sketch. Change the proportions and this is the same approach I use for drawing a street or interior spaces.

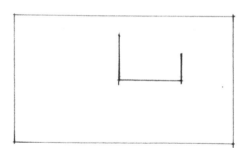

1. DRAW BASIC SHAPES
Think of a piazza as box or outdoor room without a ceiling and draw the back "wall" that defines the shape of this space. Try starting with the vertical edge on the left.

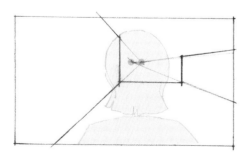

2. FIND THE VANISHING POINT
Use your pencil to extend receding lines to find the point where they intersect. Here, the two side walls are not parallel to each other, so each side has its own vanishing point on your eye-level line.

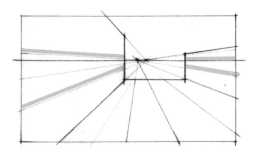

3. DRAW YOUR EYE-LEVEL LINE

Here we can see that your eye-level line and horizon line really are the same, with the VPs on that same line.

Now you have all you need to draw the accurate foundation lines of your sketch in perspective!

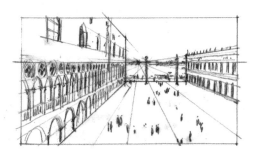

4. BREAK BIG SHAPES INTO SMALLER SHAPES

Layering in more information, add the major horizontal lines in the building faces, including a line that connects the tops of the arches. Notice how most of the horizontal lines are below eye level and angle up to the VPs.

5. ADD DETAIL AND TONE

Suggest the long rows of arches, each appearing smaller and with tighter spacing as they recede away from you.

Add people for scale, and notice how in an aerial view their heads do not align.

6. ADD COLOR

Finish the sketch with layers of simple watercolor.

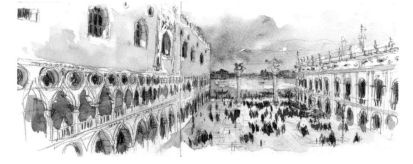

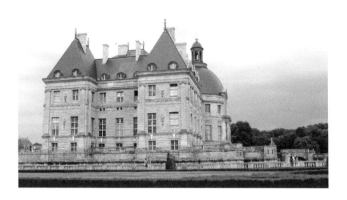

SHAPE OF THE BOX
A Two-Point, Worm's Eye-Level Perspective

What to look for

In this two-point perspective, you're viewing the Château Vaux-le-Vicomte at an angle. The principles of perspective tell us that what's closer is bigger, so the corner edge closest to you will be tallest and might be the best place to start your sketch. Steps two and three might blend a bit, as you need the VPs to draw the shapes.

1. DRAW AN EDGE

Think of this building as a box. Start to measure shapes with your pencil from the most prominent corner. This vertical edge can be a useful measuring tool, as you can compare its height to other objects in your sketch (notice the orange lines in Step 2).

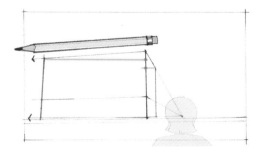

2. FIND THE VANISHING POINTS, DRAW SHAPES

Use your pencil to extend receding lines to find the points where they intersect. Here, one VP is directly in front of you and will fit on your page. For the VP to the left, use your pencil to measure the angle then transfer it to your sketch. Remember, both VPs are at your eye level.

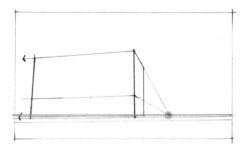

3. DRAW YOUR EYE-LEVEL LINE

Your eye level is actually below the building, so most of the building lines will angle down and appear flatter as they are closer to your eye-level line.

Now you have all you need to draw the accurate foundation lines of your sketch in perspective!

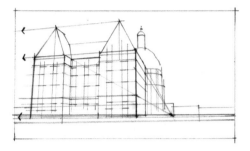

4. BREAK BIG SHAPES INTO SMALLER SHAPES

Lightly draw in guidelines to help you align the windows vertically and horizontally. Notice where the point of the roof aligns compared to the windows on the building face.

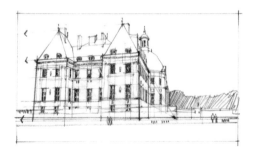

5. ADD DETAIL AND TONE

Add fireplaces, windowpanes and dark glass, the cupola over the dome, background trees, and people on the ground.

6. ADD COLOR

Finish the sketch with layers of simple watercolor. Here, the dark and stormy indigo blue sky makes the lighter building pop, adding drama to the sketch.

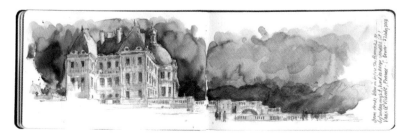

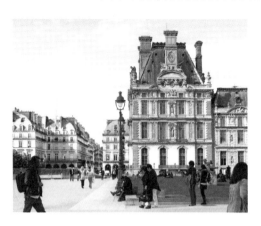

Now it's your turn...

SKETCH HERE!

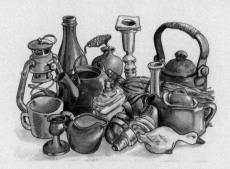

KEY V
MORE PERSPECTIVE

When sitting in your favorite cafe to sketch, how do you draw your coffee cup in perspective? And what if your cafe is in Seattle where the streets are wet with rain? We can reduce many complex forms to simple shapes that are easier to draw.

Circles and Ellipses
Arches
Domes
Reflections

♠ In Steven Reddy's still life sketch, the many circles such as the rim of cups, teapots, and bottles are seen in perspective as flattened circles called ellipses.

STEVEN REDDY
USA
Still Life with Goose
8" x 11" | 20.5 x 28 cm;
Pen, watercolor; 2 hours.
One-point/aerial view.

Circles and Ellipses

Look down at your coffee cup and what do you see? We see circles everywhere (think drinking glasses, lampshades, plates and bowls, bicycle and car tires, etc.), but they are rarely seen as true circles in shape. We see circles in perspective as flattened circles or *ellipses*. And if you understand ellipses, you can sketch arches, vaulted ceilings, and even domes in perspective.

To draw an ellipse:

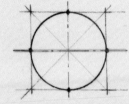 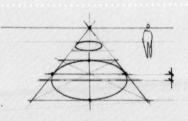

1. First, lightly draw a square in perspective, using the VPs.

2. Draw light diagonals to divide the square in half in both directions

3. Use this center point to divide the square into quarters in perspective. Where these dividing lines touch the square are the four points where the ellipse will touch the square.

4. Connect the four points with curves to draw the ellipse.

Notice, in perspective the widest point of the ellipse, the long axis shown in orange, is offset from the square's centerline. The ellipse's shape is symmetrical on both sides of this axis, not the center of the bounding square found by the diagonals.

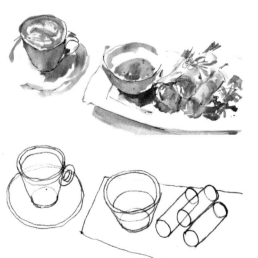

↻ Look how many ellipses are in Liz's sketch! To better understand where things are in space, sketch them as transparent.

LIZ STEEL
Australia
Coffee and Rice Paper Rolls

A4 sketchbook; De Atramentis Document Ink in Lamy pen, Daniel Smith watercolor; under 15 minutes. Two-point/aerial view.

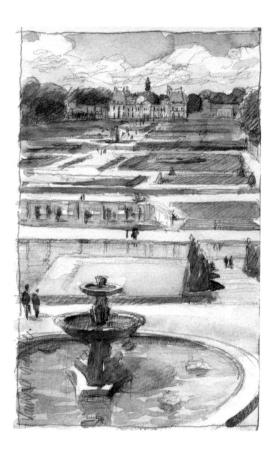

↻ The circles of the fountain at Château Vaux-le-Vicomte, France are seen as ellipses. The farther in the distance and the closer to my eye level, the flatter the ellipses appear.

Gardens at Vaux-le-Vicomte, France

8" x 5" | 20.5 x 12.5 cm; Pencil, watercolor, Pentalic Aqua Journal; about 45 minutes. One-point/aerial view.

Workshop

Try sketching rounded lampshades in your home from different eye levels. What part of the ellipses do you see when your eye level is higher than the lampshade? What about when you're below the lampshade?

⊃ **GÉRARD MICHEL**
Belgium
Rover 1904

8.25" x 11.75" | 21 x 29.7 cm;
Pigment liners, watercolor; about
30 minutes.
Two-point/eye-level view.

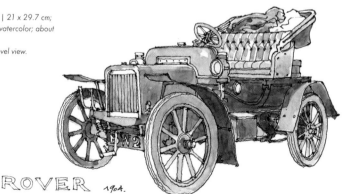

Arches

Another form that uses ellipses is the *arch*. Architecturally speaking, an arch is a curved structure that creates an opening in a solid or load-bearing wall (typically stone or brick). Arches are symmetrical about a centerline so that the weight of the wall is distributed evenly to both sides. The curved portion is a variation of a circle that starts from what is appropriately called the *spring line*. In classical architecture, you'll often see this line with ornamentation or sitting at the top of a supporting column.

The shape of the rounded portion above the spring line can tell us a lot about where or when the building was built. For example, Medieval arches are usually pointed, while Roman and Renaissance arches are typically rounded or half circles. Other types of arches are formed from multiple circles.

An arch has:

- a horizontal spring line from which the curve starts (the orange line in the diagram)
- above the spring line is a shape that is based on a circle or combination of circles
- below the spring line are two straight verticals (an arch is not shaped like a horseshoe!)

TIP

It's easier to draw the curved portion if you lightly sketch in the entire circle or ellipse.

As seen in the diagram, draw light guidelines at the top of the arch, bottom of the ellipse, the spring line, and a centerline to make sure your ellipse and arch are symmetrical.

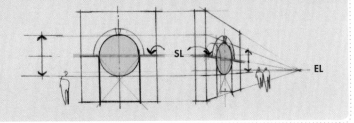

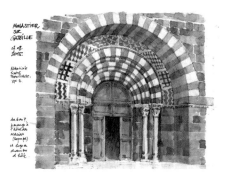

➲ Gérard's sketch shows all the elements of a true arch. See if you can find them all!

GÉRARD MICHEL
Belgium
Le Monastier, Roman church, France
8.25" x 11.75" | 21 x 29.7 cm;
Pencil, watercolor, pigment liners;
2 hours.
Two-point/eye-level view.

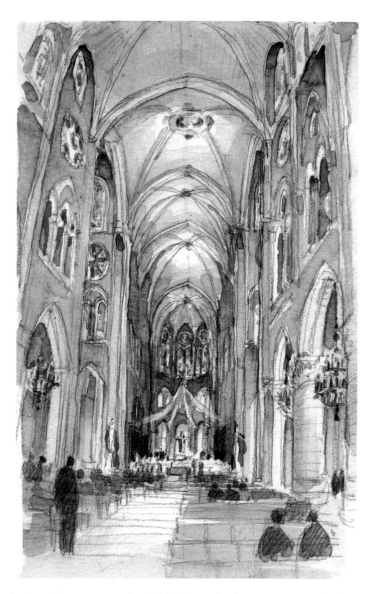

◑ The shape of the space inside the Cathedral of Notre-Dame in Paris is essentially a pointed, Gothic arch. A vaulted ceiling is a variation of an arch. I started this sketch by drawing the tall pointed arch in the center of the image.

Notre-Dame Cathedral, Paris
16" x 5" | 40.5 x 12.5 cm (cropped);
Mechanical pencil, watercolor,
Pentalic Aqua Journal; about
1.5 hours.
One-point/eye-level view.

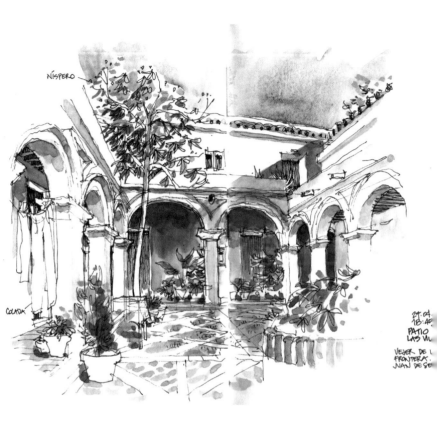

NÍSPERO

COLADA

24:09
16:40
PATIO
LAS VI

VEJER DE L
FRONTERA,
JUAN DE SE

⮑ I love to sit in quiet churches and look up. Notice how the tops of arches and the spring lines at the column capitals all align in perspective. They also mirror the arches on the opposite side of the nave.

St. James Cathedral, Seattle

5" x 16" | 12.5 x 40.5 cm; Pentalic Aqua Journal sketchbook, pencil, watercolor; about 1 hour.
One-point wide-angle/eye-level view.

Rainy dark Friday after Comish class at
St. James Cathedral Seattle · 3-28-14

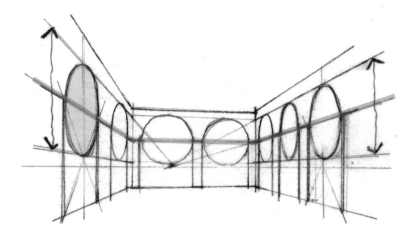

↻ In Luis Ruiz's sketch of a Spanish courtyard, multiple arches are connected to form an arcade. Drawing arches and arcades is much easier if you first draw in light guidelines that connect the tops of the arches, the spring line, the bottom of the ellipse, and where the arch hits the ground.

Look closely at this thumbnail sketch. It shows the spring line in orange turning in perspective as it hits the corners of the courtyard. The same will be true for all the lines that define the shape of the arches. Be sure to use the VP, and don't forget to add the depth/thickness of the arches.

LUIS RUIZ
Spain
Patio de Las Viudas, Vejer
8.25" x 11.75" | 21 x 29.7 cm;
Ink, watercolor; 1 hour.
One-point/eye-level view.

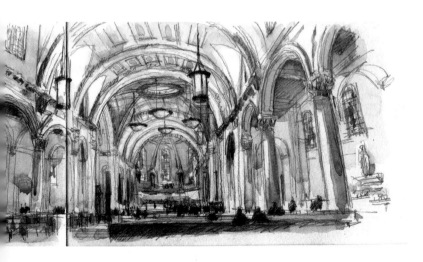

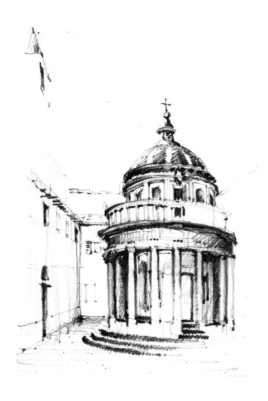

Domes

Drawing a dome is much easier if you visualize it as a three-dimensional form. Think of a dome as a series of stacked circles that appear in perspective as a stack of different-sized ellipses around one centerline.

◔ *Il Tempietto*
7" x 5" | 18 x 12.5 cm; 2B pencil; 20 minutes.
One-point/eye-level view.

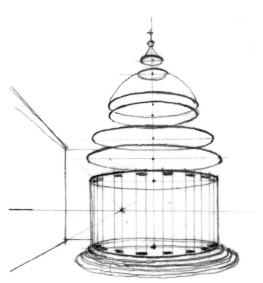

TIP

Ellipses don't have points! Be sure to show the rounded curve at the "edge" of the ellipses.

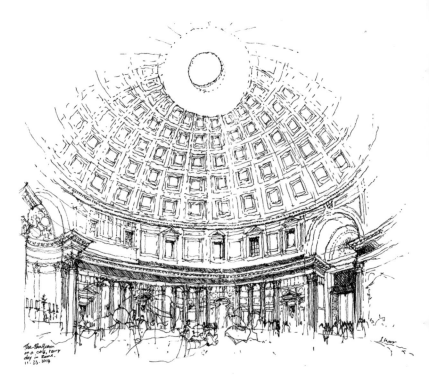

The Pantheon on a cold, rainy day in Rome. 11·23·2013

🎧 In Frank Ching's lacelike linework of the Pantheon interior, we see only part of each ellipse in the stack. Notice how the higher the ellipse (farther from his relatively low eye level), the more rounded it is. The closer the ellipses get to his eye level, the flatter they appear—foreshortening in action. Also notice how the ellipses above the eye-level line curve up, and the ellipses below the eye-level line curve down. Another reason to always draw your eye-level line in your sketch!

FRANK CHING
USA

Interior of the Pantheon

*8" x 10" | 20.5 x 25.5 cm;
Lamy fountain pen with black ink,
Moleskine journal; 1 hour.
One-point/eye-level view.*

TIP

To help you avoid a lopsided dome, lightly draw in the vertical line that connects the centers of each stacked ellipse for reference.

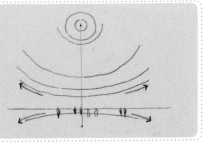

REFLECTIONS

Reflections can add a great deal of drama, light, and movement to your sketches. Water acts like a mirror, and the same characteristics apply to other reflective materials whether they are horizontal surfaces like a still lake or vertical surfaces like windows and mirrors.

Sketching reflections involves a combination of two properties: the quality of the surface (such as smooth vs. rippled water) together with reflection of lights (bright sky, glints of light) and darks (buildings, trees, mountains, etc.) into the surface. Be sure to look carefully, as the object and its reflection are not identical.

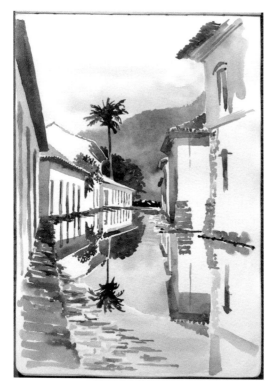

C MATTHEW BREHM
USA
Rua Dr. Pereira, Paraty, Brazil
11" x 8" | 28 x 20.5 cm;
Graphite, watercolor; 40 minutes.
Multiple VPs/eye-level view.

How do reflections work?

The key to drawing an accurate reflection is understanding where the mirrored image starts. That *line of reflection*, shown here in orange, is essentially the fold line between the object and its reflected image. The fold line is always at the level of the reflective surface. Notice that the object and its reflection share the same vanishing point, located on your eye-level line.

Here, the object and reflective surface are at the same level on smooth water. Even if the water's edge moves, as in a high or low tide, the reflection stays the same.

A = A

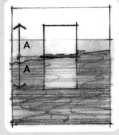 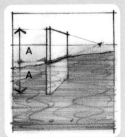

Now the object is lifted above the reflective surface, similar to Matthew's sketch on the previous page or maybe a house near a lake. To find the line of reflection, picture the water's surface continuing underground to where it intersects the location of the wall. The fold line is actually underground, at the level of the water.

A + B = B + A

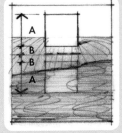 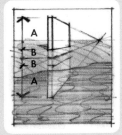

A reflection in rippled or rough water is irregular and lengthened.

A = A+

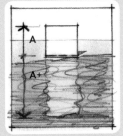

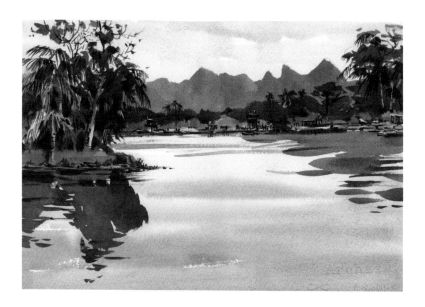

Water surface is seen in perspective too.
Ripples are larger and wider in the foreground
than in the background.
 Clouds are also seen in perspective.
They appear larger when closer to us and smaller
when seen farther in the distance.

↻ SHARI BLAUKOPF
Canada
River Kwai Morning
11" x 15" | 28 x 38 cm;
Watercolor; 2 hours.
Two-point/eye-level view.

*"Doing this sketch on site was tricky as
the view is from the road. It's a rather
rural area in Alabama so I was able to
stand at the shoulder of the road and
step in as I needed to while doing the
drawing. I changed the actual lighting
conditions to suit myself and give the
impression of a wet road casting
reflections." – Iain Stewart*

➲ Iain's sketch is all about
the glow in the sky and
how it's reflected into the
bridge. Notice how he paints
reflections straight down but
also layers in a few slightly
angled horizontal lines to
indicate the surface of
the roadway.

IAIN STEWART
USA/Scotland
Drawbridge Coden, Alabama
10" x 6" | 25.5 x 15 cm;
Berol 314 pencil, watercolor,
Arches 140lb. cold press; 1 hour.
One-point/eye-level view.

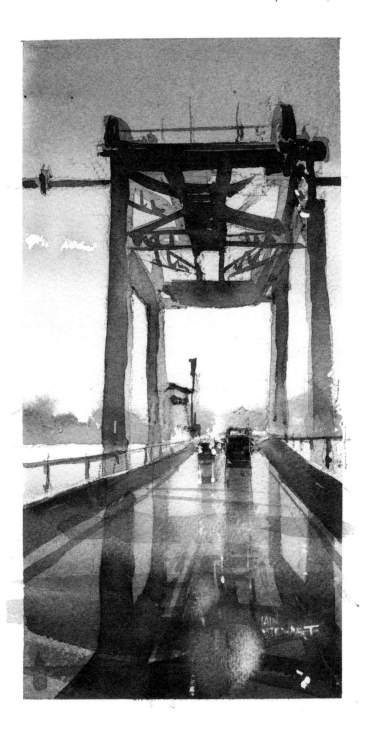

SKETCH HERE!

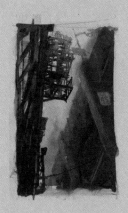

GALLERIES

These pages feature artists who stretch, pull, bend, and push the principles of perspective in creative ways.

"It was a very grey overcast day and what got my attention was the shape of the sky between the viaduct and the buildings. I wanted to change the time of day and light quality to be more twilight and moody... more in keeping with the scary elements... an aging viaduct scheduled to be demolished and the fire escapes that have been rusting in the weather for a hundred years ..."
– Bill Hook

◯ **BILL HOOK**
USA
Study for Scary Stuff
6" x 4" | 15 x 10 cm;
Watercolor, sketchbook;
30 minutes.
One-point/worm's-eye view.

WIDE-ANGLE VIEWS
in Perspective

Wide-angle perspectives capture a bigger view by stretching the normal lines of perspective to exaggerate a sense of width or height.

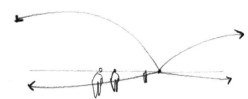

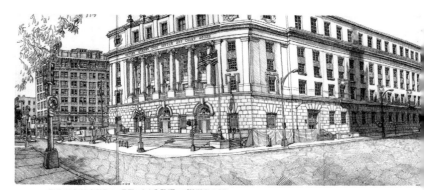

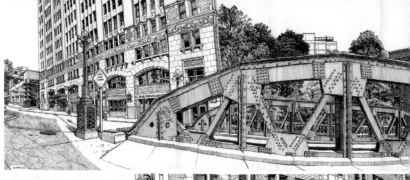

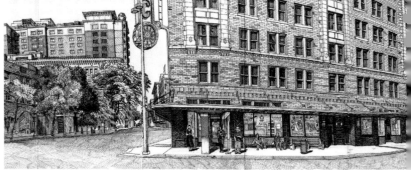

◑ These sketches by extraordinary artist Paul Heaston combine two areas in which he excels. He creates tone, intricate texture, and a sense of architectural materials by building up small strokes of line, a process called "hatching." He is also a master at complex wide-angle perspective views where he curves the horizontals and verticals to give a fish-eye lens effect.

PAUL HEASTON
USA

3 ½ San Antonio panoramas

*8" x 10.5' | 20.5 cm x 3.2 m;
Staedtler Pigment Liners, Japanese
folding Moleskine sketchbook;
about 3 months.*
Multiple VPs/eye-level views.

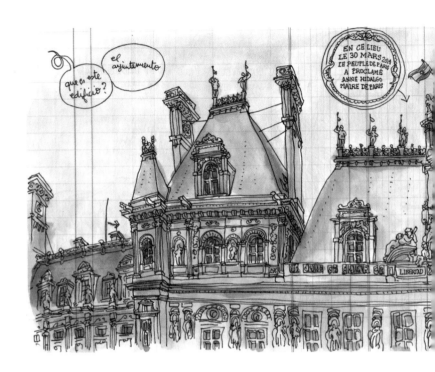

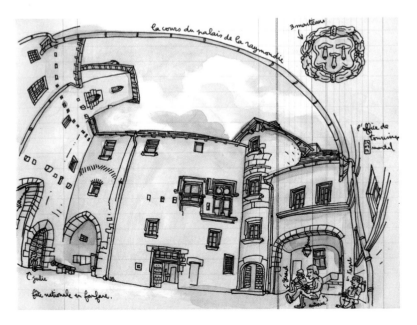

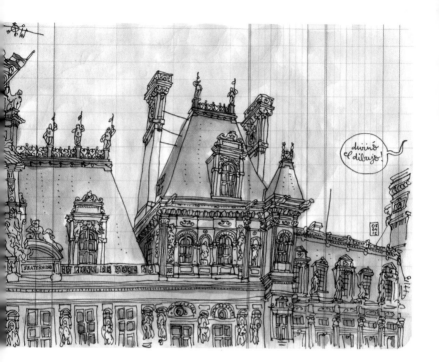

Without a doubt, Lapin's amazing sketches can induce a smile. His sketches are full of personality and sometimes include portraits of people with whom he is sketching. Lapin's wide-angle views really distort the horizontals and verticals to extreme curves, with the tops of the buildings often bending over to take a look at his sketch. These images are filled with detail and movement, sketched on Lapin's signature vintage accounting books.

⋒ LAPIN
Spain

Hôtel de Ville, Paris

6" x 16.5" | 15 x 42 cm;
Ink pen, watercolor, colored
pencils, old accounting book;
1.5 hours.
Wide-angle /worm's-eye view.

C *Martel*

6" x 8.25" | 15 x 21 cm;
Ink pen, watercolor, colored
pencils, old accounting book;
1 hour.
Wide-angle fish eye/eye-level view.

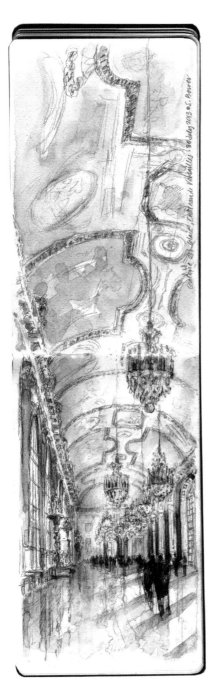

Caroline M. Luino, Château de Versailles; 30 July 2013 ©J. Borrer

↻ This vertical wide-angle view is all about the dramatic painted and gilded ceiling of the Galeries des Glaces at Versailles. The space is so ornamented and so complex, with hundreds of people passing by and into the view that my head was spinning after an hour.

This sketch simply turns the book to a vertical format, places the eye-level line and VP very low on the page, then keeps going in perspective until I'm sketching what is directly over my head.

Galeries des Glaces, Versailles

16" x 5" | 40.5 x 12.5 cm; Pencil, watercolor, Pentalic Aqua Journal; about 1.5 hours. One-point/eye-level view.

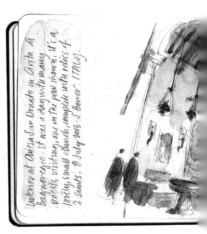

Wide-angle views can go across and up and down!

In a slightly different style of wide-angle sketch, the Chiesa San Donato interior has a fairly normal one-point perspective near the center of the image, but as the building's arches get closer to me on either side, the vertical lines increasingly tilt to a VP in the sky. I love how this distortion exaggerates the height and gives the feeling of being in the space.

↻ *Chiesa San Donato, Civita di Bagnoregio, Italy*

5" x 16" | 12.5 x 40.5 cm; Pencil, watercolor, Pentalic Aqua Journal; about 1.5 hours. One-point wide-angle/eye-level view.

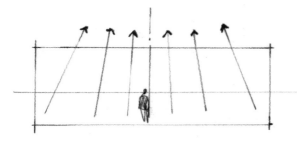

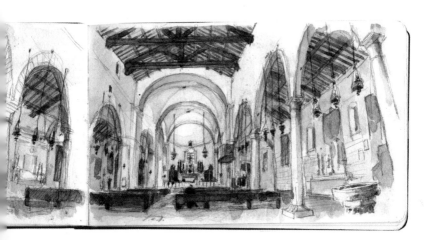

TEXTURES in Perspective

⋒ KK's background in architecture and Chinese calligraphy is evident in his amazing drawings. He builds up the textures of the materials in perspective (look at the tiled roofs), using wood twigs dipped in ink—he makes his own tools. It's phenomenal how his delicate linework and textures enter and exit his sketches. He simply adds additional pieces of paper when he wants to extend the panoramic view.

CH'NG KIAN KIEAN
Malaysia
Rio Pereque Acu, Paraty
11" x 59.75" | 28 x 152 cm,
Quadriptych; Chinese ink,
watercolor paper; about 3 hours.
One-point/eye-level view.

⋒ Simone builds up the textures in her sketches with lots of delicate linework. She then applies a limited palette of colors using loose washes, dribbles, and splatters to infuse the sketch with energy and movement.

SIMONE RIDYARD
England
Singapore
5" x 16" | 12.5 x 40.5 cm;
Ink, watercolor; 30 minutes.
One-point/eye-level view.

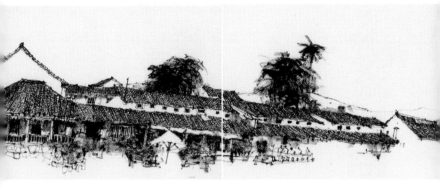

❂ Jamie has a background as an architect and architectural illustrator, so his use of perspective is spot-on accurate. He has an amazing drawing hand and is able to build up a sense of light and dark using a classical style of hatching textures. In particular, the direction of the stone paving provides a sense of depth and space to the piazza.

JAMES AKERS
USA
Montepulciano
5.5" x 7.5" | 14 x 19 cm;
Razor Point felt tip pen,
bond paper; 1.5 hours.
Multiple VPs/eye-level view.

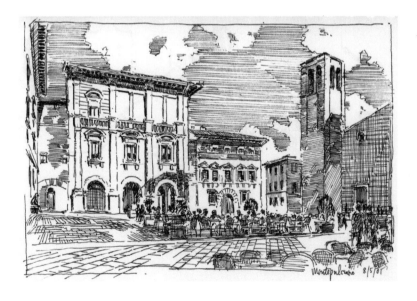

PAINTINGS in Perspective

The work on these pages features extraordinarily talented, award-winning artists whose background is in architecture and architectural illustration. They are also remarkable plein air sketchers. In addition to having a great sense of color, their knowledge of perspective provides the foundation in much of their work.

⌁ The buildings in Michael Reardon's paintings seem to glow from within. The architecture looks solid but almost floating, detailed without being detailed. The glow of the shade and shadow gives his work an atmospheric sense.

MICHAEL REARDON
USA

Santa Maria della Salute, Venice

14" x 9" | 35.5 x 23 cm; Transparent watercolor, Arches watercolor paper; 2 hours. Two-point/eye-level view.

◑ **IAIN STEWART**
USA/Scotland

Downtown Los Angeles

10" x 14" | 25.4 x 35.5 cm;
Berol 314 pencil, watercolor,
Stillman & Birn Beta series loose
sheet paper; 1 hour.
One-point/eye-level view.

"I did this sketch while standing in front of an 18 wheeler. Bill was around the corner and Tom was behind me doing a painting of one of the many bridges that cross the LA River. With no warning the driver of the truck started it up. I nearly dropped my brush." – Iain Stewart

⮜ Tom Schaller travels the world sketching and painting. With his background as an architect and top architectural illustrator, his work has a strong sense of dramatic perspective. He often contrasts intense darks against lights to heighten the sense of depth and movement.

THOMAS W. SCHALLER
USA

Vertical Study, 14th Street, NYC

18" x 12" | 45.5 x 30.5 cm;
Pencil, watercolor, Fabriano paper; 1 hour.
One-point/eye-level view.

⮝ **THOMAS W. SCHALLER**
USA

Bike, Bridge, Berlin

13" x 18" | 33 x 45.5 cm;
Pencil, watercolor,
Fabriano Artistico; 1 hour.
Two-point/eye-level view.

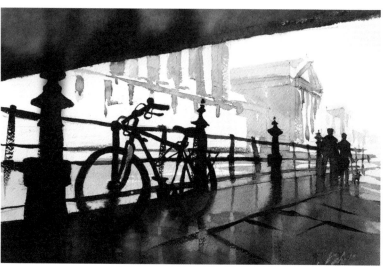

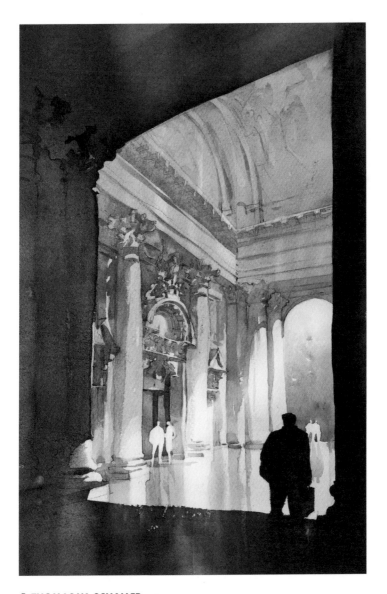

◑ **THOMAS W. SCHALLER**
USA

Berliner Dom

20" x 14" | 51 x 35.5 cm;
Pencil, watercolor, Saunders
Waterford; 2.5 hours.
Two-point/eye-level view

LEARNING in Perspective

These perspective sketches are part of a study
that documents the historic hill town of Civita di
Bagnoregio, Italy. A form of visual note-taking,
each image is a wide-angle/180°-degree view
that stretches the scene from ear to ear, giving the
viewer the feeling of what it was like to be in that
space. And of course, these images trigger my
memories of the Italian sun, the colors, the people,
and so much more. Snapping a photo wasn't
enough; I had to sit, observe, and record in
order to learn.

In the end, urban sketching is a way to
learn about the world around us. Sketchers are
notoriously curious about the things they observe,
which is why so many like to travel and record
their experiences.

Tools now in hand, learn about your world
wherever you are, by sketching!

*Views of Civita di
Bagnoregio, Italy*

*8" x 16" | 20.3 x 40.6 cm;
Mechanical pencil with 2B lead,
watercolor, Fluid watercolor block;
about 1 hour each.
Wide-angle one-point/eye-level views.*

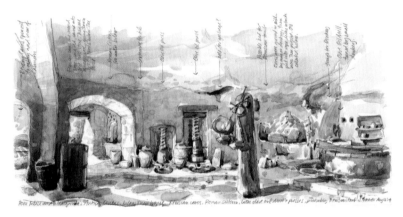

CHALLENGES

Here are some sketching challenges to try. You'll start to see perspective everywhere!

1. ☐ Draw a window or doorway in elevation.

2. ☐ Draw a narrow street.

3. ☐ Draw light or electric poles along a street.

4. ☐ Draw a series of windows in perspective.

5. ☐ Draw from an upper floor looking out a window.

6. ☐ Draw stairs going up.

7. ☐ Draw stairs going down.

8. ☐ Draw an arch.

9. ☐ Draw a series of arches in perspective.

10. ☐ Draw cereal boxes on your kitchen table.

11. ☐ Draw transparent cereal boxes to see the real shapes.

12. ☐ Draw your meal as if your dishes were transparent.

13. ☐ Draw rounded lampshades from above.

14. ☐ Draw rounded lampshades from below.

15. ☐ Draw the interior of a church.

16. ☐ Draw the space of a courtyard.

17. ☐ Draw a wide-angle view.

18. ☐ Draw a worm's-eye view looking up.

19. ☐ Draw your tea or coffee cup from different heights.

20. ☐ Draw a one-point perspective of a room.

21. ☐ Draw a two-point perspective of the same room.

22. ☐ Draw the same room while standing on a chair.

23. ☐ Draw a building at the beach, looking at the water.

24. ☐ Draw a sketch out an airplane window.

25. ☐ Create your own challenges!

☾ ROB SKETCHERMAN

Hong Kong

Penang Night Hawkers

4096 x 3000 pixels;
Procreate app on iPad Air with a
modified Wacom Intuos Creative Stylus
(1st gen); time (2 hours)
One-point/eye-level view.

CONTRIBUTORS

Akers, James W.
New York City
akersdesignrender.com

Bajzek, Eduardo
São Paulo, Brazil
ebbilustracoes.blogspot.com

Blaukopf, Shari
Quebec, Canada
blaukopfwatercolours.com

Bondarenko, Evgeny
Rostov-on-Don, Russia
evgenybondarenko.com

Boon Sim, Tia
Singapore
tiastudio.blogspot.com

Bower, Stephanie
Seattle, WA USA
stephaniebower.com

Brehm, Matthew
Moscow, ID USA
brehmsketch.blogspot.com

Campanario, Gabriel
Seattle, WA USA
gabicampanario.com

Ch'ng Kian Kiean
Penang, Malaysia
kiahkiean.com

Chamness, David
Seattle, WA USA
chamnessdrawpaint.blogspot.com

Ching, Frank
Seattle, WA USA
frankching.com

Copeland, FAIA, Lee
Seattle, WA USA
mithun.com

Dewhurst, Murray
Auckland, New Zealand
aucklandsketchbook.com

Dorantes, Norberto
Buenos Aires, Argentina
norbertodorantes.com.ar

García García, Alfonso
Seville, Spain
flickr.com/photos/
79614328@N07/

Hanchett, Josiah
Grand Rapids, MI USA
jdhanchett.com

Heaston, Paul
Denver, CO USA
instagram.com/paulheaston

Holmes, Marc Taro
Montreal, Canada
citizensketcher.com

Hook, William G.
Seattle, WA USA
wghook.com

Johansson, Nina
Stockholm, Sweden
ninajohansson.se

Johnson, Richard
Washington DC, USA
newsillustrator.com

Lapin
Barcelona, Spain
lesillustrationsdelapin.com

Lee, Chris
Somerset, UK
chrisleedrawing.co.uk

Lynch, Fred
Winchester, MA USA
fredlynch.com

Maskin, Alan
Seattle, Washington
olsonkundig.com

Michel, Gérard
Liège, Belgium
flickr.com/photos/gerard_michel/

Moll, Guy
Faro, Portugal and France
guymoll.com.sapo.pt

Reardon, Michael
Oakland, CA USA
mreardon.com

Reddy, Steven
Seattle, WA USA
stevenreddy.com

Richards, James
Fort Worth, TX USA
jamesrichardssketchbook.com

Ridyard, Simone
Manchester, UK
simoneridyard.co.uk

Ruiz, Luis
Málaga, Spain
luisrpadron.blogspot.com

Schaller, Thomas W.
Marina del Rey, CA USA
thomasschaller.com

Shirodkar, Suhita
San Jose, CA USA
sketchaway.wordpress.com

Sketcherman, Rob
Hong Kong
sketcherman.com

Smith, Clark
Sharon, CT USA
clarksmithrendering.com

Soheylian, Jérémy
Semur-en-Auxois, France
jeremy-soheylian.fr

Steel, Liz
Sydney, Australia
lizsteel.com

Stewart, Iain
Opelika, AL USA and Scotland
stewartwatercolors.com

Wang, Paul
Singapore
flickr.com/photos/fireflyworkshop

Wong, Gail
Seattle, WA USA
glwarc.com

ACKNOWLEDGMENTS

My heartfelt thanks to all the artists from around the globe who so generously contributed to the pages in this book. Your passion and talent for capturing your world is inspiring. To the talented fellow-Seattle sketcher Gabriel Campanario, I am so grateful to you for this opportunity.

Many thanks to those who contributed to the making of this book, including Quarry Books editor Mary Ann Hall and project manager Betsy Gammons. Your art is in this book as well! Thanks also to my friends with keen eyes and clear minds who reviewed the draft—Beanne Hull, Nancy Haft, Béliza Mendes, Kate Buike, and model Lené Copeland.

My gratitude to the professors at the University of Texas at Austin School of Architecture—George Villalva, Jorge Luis Diviñó, Larry Speck, and Sinclair Black—who taught generations of architects like me to draw and think with a pencil.

I am so grateful to everyone associated with the Gabriel Prize, an architecture fellowship that encourages the learning about architecture through drawing on location in France. The three remarkable months spent in Paris allowed me the unprecedented opportunity to study and create a large body of work, which has now opened so many doors.

This book would not have been possible without the support of my husband, Rich, and sons, Nicholas and Peter, who not only encouraged me to pursue my dreams, but also held down the fort during sometimes long sketching travels around the globe. I love you.

And finally, deepest thanks to Ralph Pearson, whose generosity sparked these sketching adventures... and changed my life.

ABOUT THE AUTHOR

Twice honored with the KRob Architectural Delineation award for Best Travel Sketch and the 2013 Gabriel Prize architecture fellowship, Stephanie Bower is a Seattle-based architectural illustrator, teacher, watercolorist, and traveling Urban Sketcher. The many facets of her life and career have come together to create The Urban Sketching Handbook: Understanding Perspective.

Stephanie worked as a licensed architect in New York City before gravitating to professional architectural illustration and concept design. In Seattle, she produces pencil and watercolor perspectives for many renowned architecture and design firms.

For more than twenty-five years, Stephanie has taught the how-to's of architectural sketching— for a decade in New York City at Parsons, in Seattle at the University of Washington and Cornish College of the Arts, and most recently, in popular sketching workshops called "Good Bones." She was an instructor at the 2014 and 2015 Urban Sketchers Symposiums in Brazil and Singapore and also teaches an annual workshop in Civita di Bagnoregio, Italy. Her online course "Perspective for Sketchers" can be found on Craftsy.com. She is a signature member of the Northwest Watercolor Society.

People around the world follow her sketches online via Flickr, Facebook, her blog "Drawing Perspectives," and as blog correspondent for Urban Sketchers. To see more of Stephanie's work, please visit www.stephaniebower.com.

Stephanie continues to learn about architecture through her sketches, pursuing her lifelong dream of seeing the world, sketching, teaching and encouraging others to see their world through the magic of drawing.